GOTHIC LOLITAS

HOW TO DRAW MANGA STEP BY STEP

This edition published in 2010 by
Search Press Ltd
Wellwood
North Farm Road
Tunbridge Wells
Kent TN2 3DR
www.searchpress.com

ISBN: 978-1-84448-598-7

This book was conceived, designed and produced by

maomao publications
Via Laietana, 32 4th fl. of. 104
08003 Barcelona, Spain
Tel.: [34] 93 481 57 22
Fax: [34] 93 317 42 08
mao@maomaopublications.com

Publisher: Paco Asensio
Editorial Coordination: Anja Llorella Oriol
Illustrations: Sergio Guinot Studio, www.artesecuencial.com
Texts: Sergio Guinot Studio, www.artesecuencial.com
English translation: Cillero & de Motta
Art Direction: Emma Termes Parera
Layout: Esperanza Escudero Pino
Cover design: Emma Termes Parera

Printed in Spain

GOTHIC LOLITAS

HOW TO DRAW MANGA STEP BY STEP

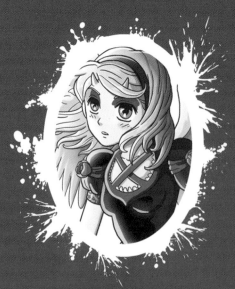

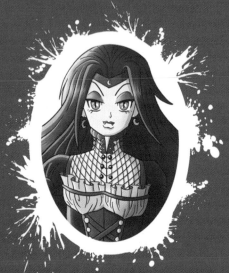

TABLE OF CONTENTS

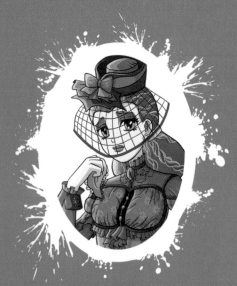
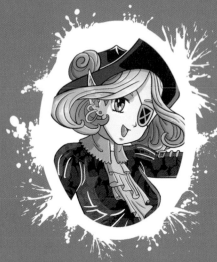

INTRODUCTION

Welcome to this book. Behold the Gothic Lolitas as you have never seen them before. This book explains how to create, outline, sketch, draw, ink, shadow and finish a wide variety of young women that represent the growing urban tribe of the Gothics, tailored to all situations: current, working, past, future, fantasy and horrific Gothic Lolitas ...

This guide has been adapted to suit both those who use computer programs to create illustrations, and those who prefer a more traditional style of drawing, i.e. pencils, nibs, watercolours, etc.

On your journey you will cover the basic principles of drawing, applied to the world of Gothic Lolitas, and will use different exercises of varying complexity. If you follow the instructions carefully, you too will be able to bring these dark and attractive characters to life.

I hope that you enjoy this book and that you find it useful.

Sergio Guinot

General Comments I: Outline and Sketching

For the outlines, I will use simple feminine figures as a base, although when dealing with manga, the head will be of a slightly larger size than normal. The framework of lines will be drawn with circles for the joints, which serve as a guide for the sketch of each figure. When doing this, you must keep in mind the following general rules about manga girls: the head is normally quite big, accompanied by a thick mane of hair. The arms are thin and stylised. The waist is fairly high and narrow. The hips are always wider and more rounded.

General Comments II: Pencilling and Inking

Pencilling does not have to be perfect. It can be quite rough and sketchy. Apply different layers, or erase and correct when necessary, to achieve a pencilling that you are happy with. It is in the subsequent inking stage that you will clean up the imperfections and apply detail to the various elements. If your pencilling is detailed, the inking will be a simple process and you will therefore be able to concentrate on achieving an elegant line.

General Comments III: Colour

Gothic Lolitas choose black as the main colour for their wardrobe. They also opt for blood reds and magic violets, although they will wear any colour that makes them appear dark and mysterious. Here I have tried to use a wide range of colours. To avoid your colour scheme appearing dull, you need to give it the appropriate contrast, that is, a touch of colour that stands out from the general tone of the illustration, providing the viewer with a rich array of tones.

General Comments IV: Lighting, Shading and Finishing Touches

Very specific shading is used in both manga and anime, characterised by the highly detailed areas of light and shadow with a distinct lack of grading. This is the method that has been used in this book, applying a simple rule that gives very good results: add light (using transparent layers of white) to the side of the face that is looking towards to light source, and shadow (using black layers of low opacity), to the other side. Lighting and shading are essential to define the elements that make up the character and to give it volume. What is more, you can use them to improve the detail of the drawing or to clarify one of its more obscure areas.

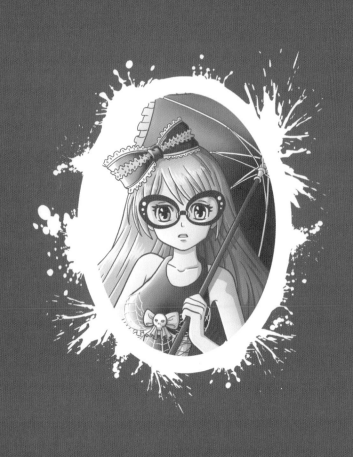

GOTHIC LOLITAS
OF TODAY

Gothic Lolitas were born when girls who loved the Lolita style decided to adopt a more Gothic aesthetic, some of the strongest among today's urban tribes.

Gothic Lolitas wear mostly a combination of over-elaborate Victorian suits covered in lace trim, bows and ribbons predominantly in black and white. Although the basic wardrobe is covered in this book, I have tried to go one stage further and show how the Lolitas adapt their attire to different situations and events, mixing their beloved black with different colours, hairstyles and accessories. In this chapter you will see six Gothic Lolitas who proudly sport their sinister style in different situations, some from everyday life and more typical of the Lolitas, and some other more surprising and even unthinkable ones, from the vampirical style of Lilith Alexia (captain of the Vamps Cheerleaders), to the glamorous cocktail dress of a blonde Gothic Beauty (Emma Shadow).

Lilith Alexia
Gothic
Cheerleader

The captain of the Vamps Cheerleaders knows very well how to surprise the opposition. She sets the trend with the sporty Gothic style and sends a very clear message: She toys with fear!

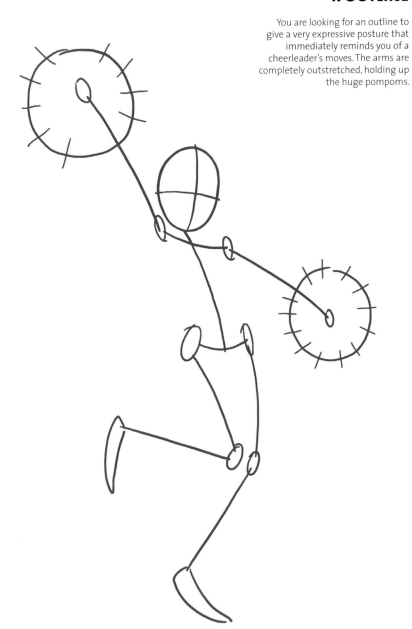

1. OUTLINE

You are looking for an outline to give a very expressive posture that immediately reminds you of a cheerleader's moves. The arms are completely outstretched, holding up the huge pompoms.

2. SKETCHING

Here you give volume to the character. The body of the woman has a V shape. The hips are normally much wider than the waist. Her back is arched and her chest is pointed upwards to show that Lilith is jumping.

3. PENCILLING

It is at this stage that you draw in all of the details that you want to add to the character. Use colours to clarify small details and avoid complicated pencilling.

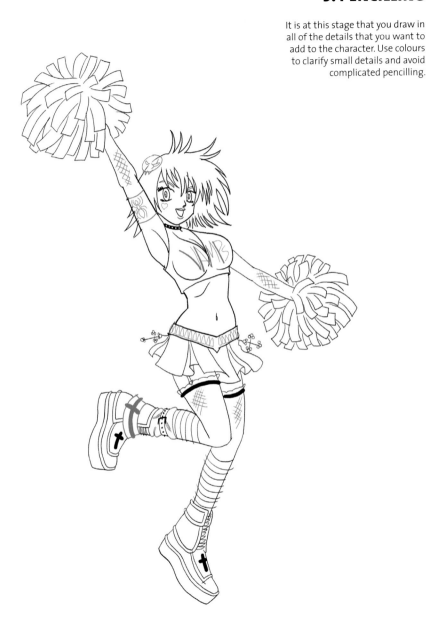

4. INKING

The traces of ink that you apply here are well defined, to ensure that they are clear and elegant. If you are sure about where they should go, you can add the areas of black.

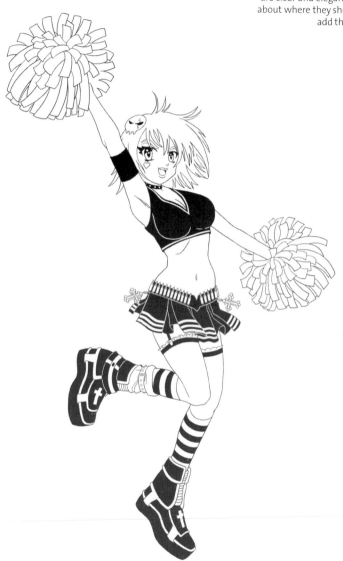

5. Lighting and Shading

If you have the choice, it is preferable for the light to hit the character from the front, as this allows you to better visualise it. Two layers of shade will give volume to the body and the pompoms.

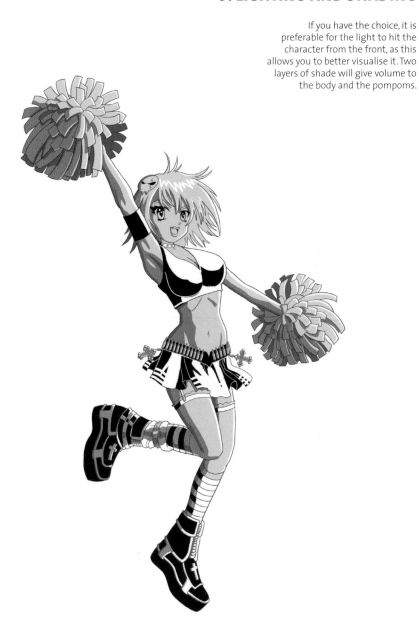

6. Layers of Colour

Different tones of blood red
dominate the upper part of the
drawing, forcing you to look
upwards as the character jumps.
The shades of violet tone down the
lower section.

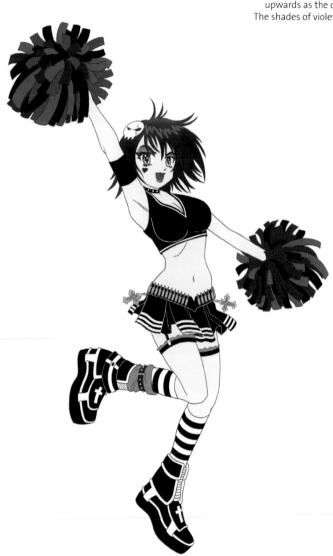

7. Finishing Touches

To finish the drawing, bring together all of the previous stages and add details like the Vamps' logo, the tattoo and the decoration on the shoes, socks, armband and pompoms.

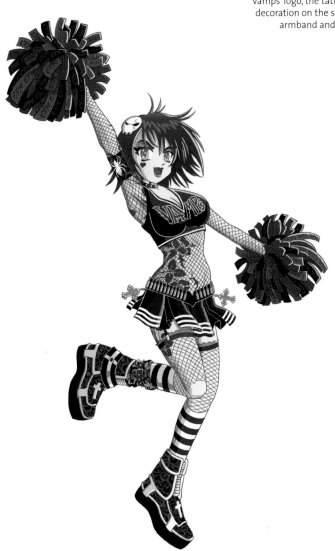

HANNA
BLACKROW
GOTHIC STUDENT

Hanna is a very special student with a captivating personality. She loves the Gothic style and takes it to the extreme. Her cool accessories are the envy of all of her classmates.

1. OUTLINE AND SKETCHING

Outline the figure standing balanced on one leg. The arms, one bent and the other outstretched, complete this dynamic posture. The arched back and upheld head portray happiness.

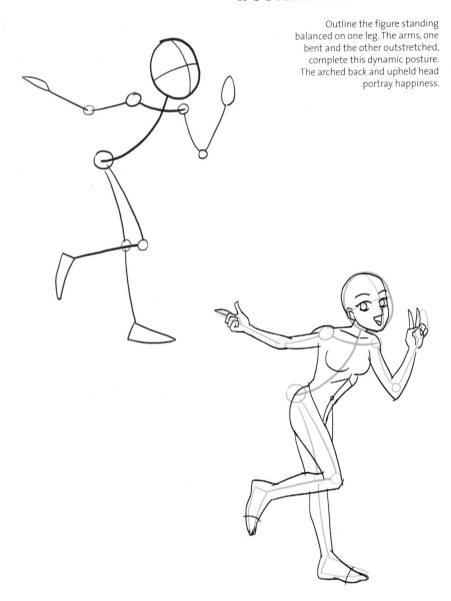

2. Pencilling and Inking

The skirt and the hair are raised in movement, while the hat gives a touch of chic. Apply a detailed layer of ink to the lace edging. The areas of black are distributed in such a way that they balance the weight of the figure.

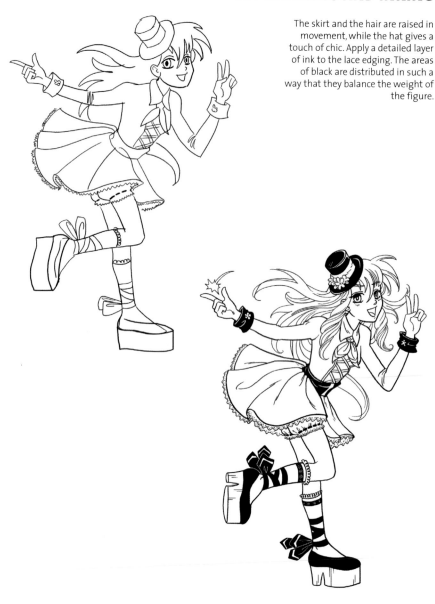

3. Layers of Colour

The grey and the violet are typical of the Gothic style. The big mass of blue hair gives the character real personality.

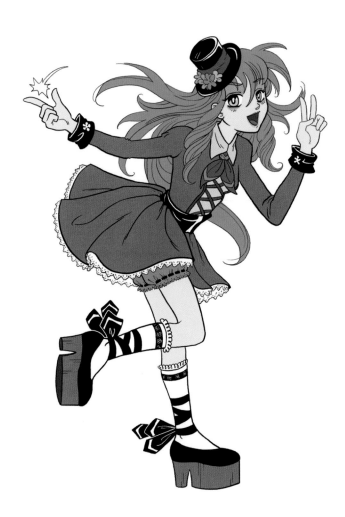

4. Lighting and Shading

In this case I have used lighting
and shading more stylistically
than practically. This does not
add so much to the character's
volume, but allows us to embellish
the illustration.

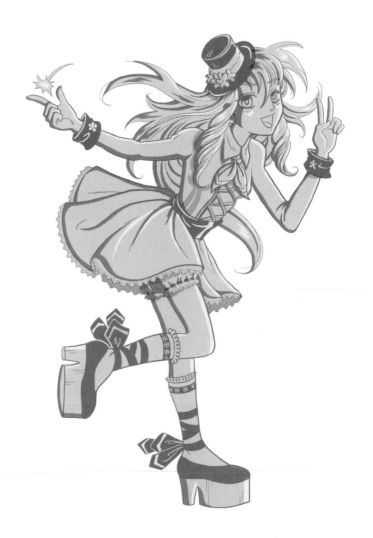

5. Finishing Touches

To complete the illustration's detail,
add criss-crossed lines and skulls
to the dress. Adorn the socks with
complex floral motifs.

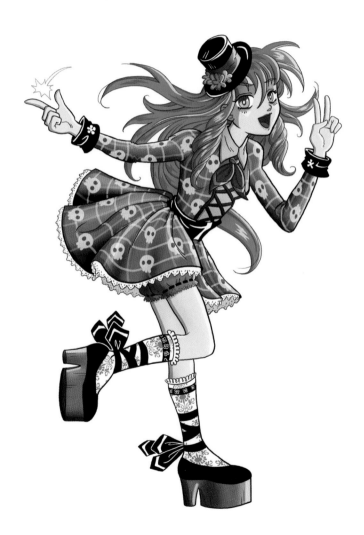

CRAZY MAXY
GOTHIC CYBERPUNK

Crazy Maxy is a complete contradiction. She is very shy and carries her worn-out teddy bear wherever she goes. However, her clothes and hairstyle are both aggressive and provocative.

1. OUTLINE AND SKETCHING

The outline portrays an unsure figure with a hesitant gait. A teddy bear that seems to weigh a ton hangs from her hand. It is hidden even more with the shading, to represent Maxy's shyness.

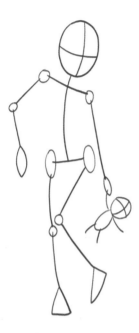

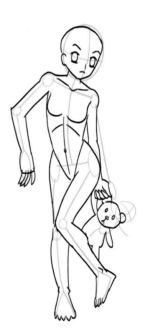

2. Pencilling and Inking

Maxy is dressed in aggressive platform boots, a tight bodice and large pigtails, which contrast with her personality as much as the spikes contrast with the ribbons. The black areas dominate the inking.

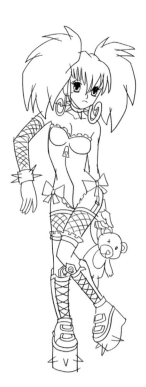

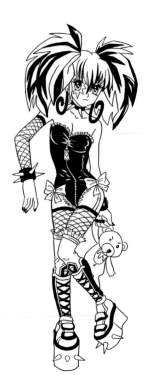

3. Layers of Colour

I have used a combination of colours as mad as the character. The orange on Maxy's face balances the warm colours of the bear, a reminder of her secure childhood.

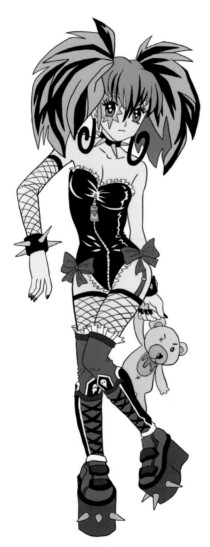

4. LIGHTING AND SHADING

To add to the bizarre nature of the picture, position the light source to the left. With her skewed head tilted to the right, Maxy gives the impression that she would rather hide in the shadows.

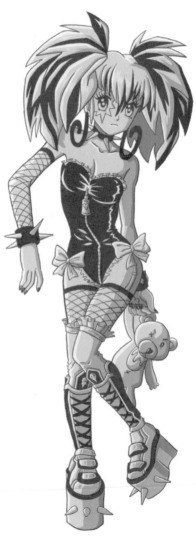

5. Finishing Touches

The complex decoration of the outfit and the arm tattoos help to accentuate the character's Gothic personality. Add a light sheen to the boots using faint shading.

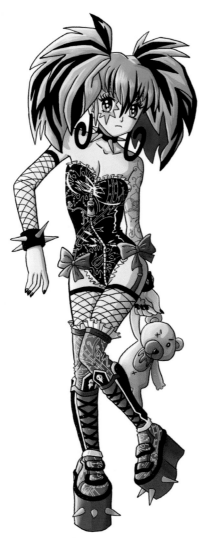

EMMA SHADOW
GOTHIC BEAUTY

Emma Shadow is a melancholic beauty who always maintains a perfect posture. Although dark in nature, she likes to dye her hair blonde to rebel, even to her Gothic friends.

1. OUTLINE AND SKETCHING

Outline the character leaning, perhaps on a table or the bar of her favourite café. In the sketching stage, draw her head resting in her hand, showing boredom and melancholy.

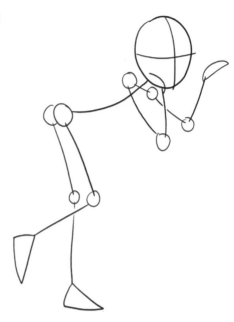

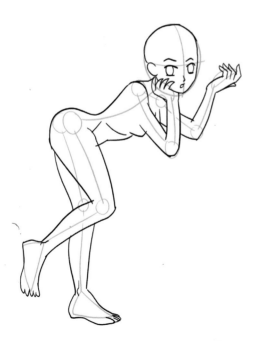

2. Pencilling and Inking

Although she is Gothic, Emma is a vain girl, and you can see this from the large bow in her hair. She has a bat tattoo on her shoulder and in her hair she has two clips in the shape of broken hearts.

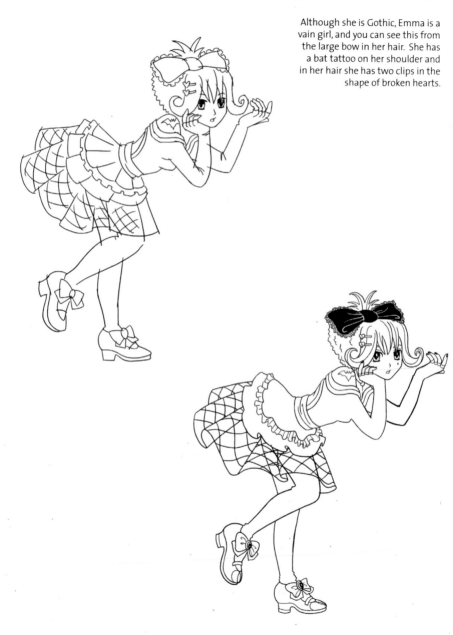

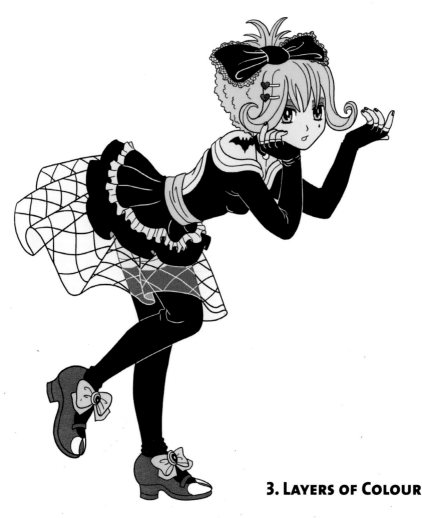

3. LAYERS OF COLOUR

The yellow colour defines the
character. The sash and the bows on
the shoes balance the yellowness
of her hair. The skin is pallid next to
the blue of her eyes.

4. Lighting and Shading

Since the drawing is dominated by the large black areas together with very bright colours, lighting and shading have limited effect. Even so, the light allows you to bring out the shine of the black.

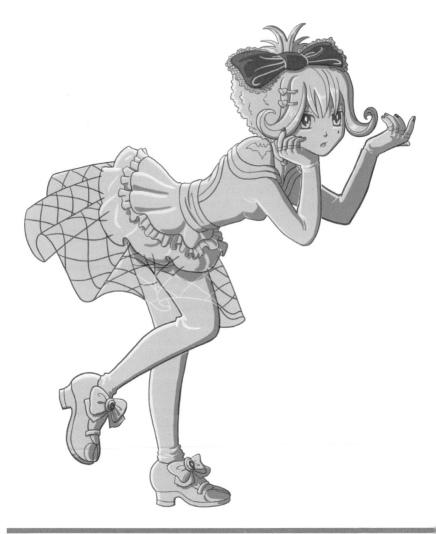

5. Finishing Touches

The only details added here are the hearts and diamonds, which, being white and red, contrast strongly with the stockings. As a finishing touch, a transparent layer is added for the net skirt.

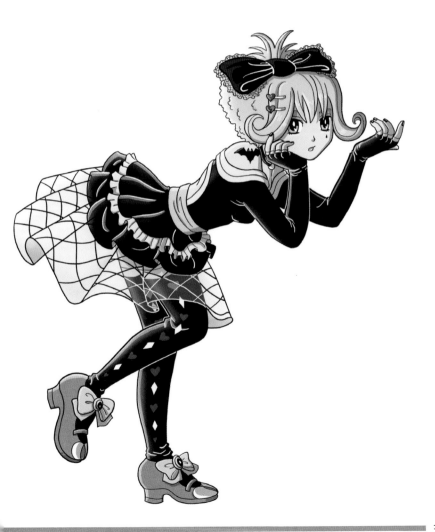

JAIZZA
ULLMER
GOTHIC BIKINI

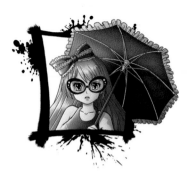

Jaizza Ullmer is completely out of place because Gothics don't like going to the beach. Even so, Jaizza keeps the purely Gothic style of which she is so proud.

1. Outline and Sketching

The upright figure holds herself with an elegance that accentuates her femininity. The parasol over the shoulder and the slightly elevated hand gives a touch of distinction to the curvaceous sketching.

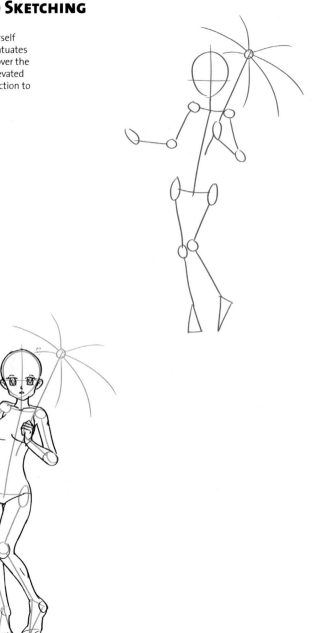

2. PENCILLING AND INKING

This is a very balanced character, and her clothes and accessories match elegantly. Her plastic-rimmed glasses give a retro feel that takes us back to the 60s. The inking is fine and elegant.

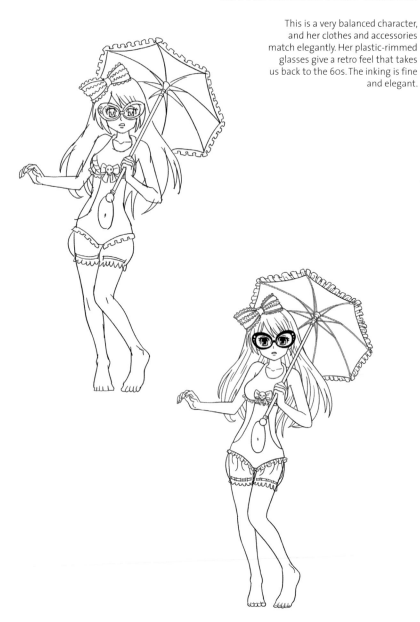

3. Lighting and Shading

The use of light and shade is very subtle, and only to add volume. It is worth pointing out the elaborate lighting of the hair that balances the detailed ink work.

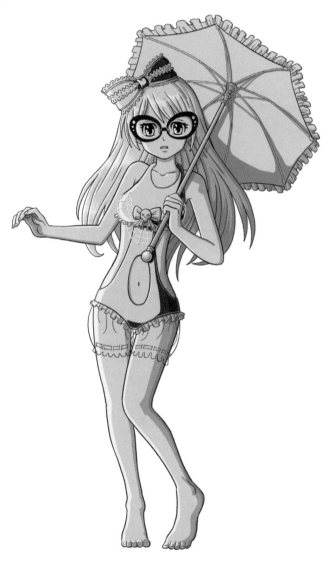

4. Layers of Colour

Here you combine the character's blacks with tones of pink. The hair stands out thanks to a deeper pink, almost a fuchsia.

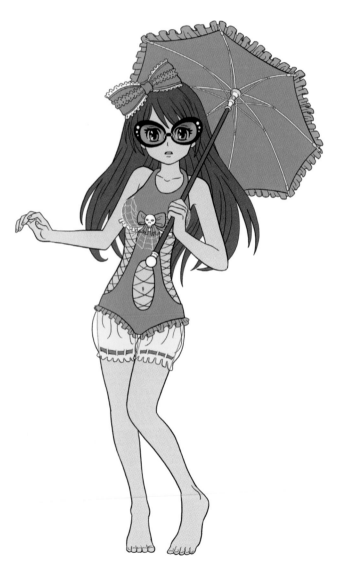

5. Finishing Touches

To give more of a 3D effect, add prominence and dimension to the chest and similar shading to the fishnetting on the stomach.

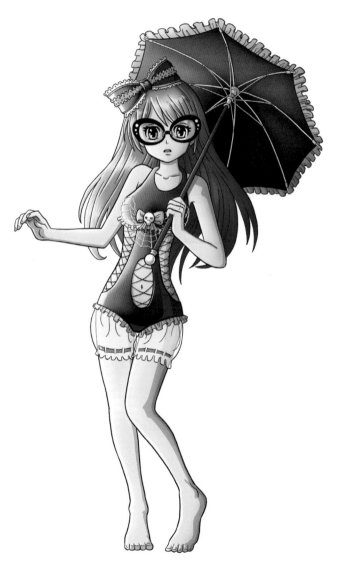

2. PENCILLING AND INKING

Draw the rather special pyjamas, with a small body, wide sleeves and covered with polka dots. You can tell the position of the viewer from the multitude of cushions upon which Alice is resting.

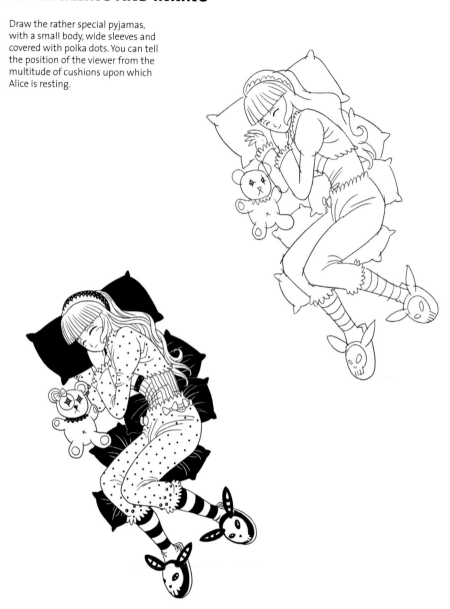

3. LAYERS OF COLOUR

The chocolate brown colour is warm and relaxing, ideal for a peaceful snooze, and goes perfectly with the violets of the bows and the hairband. Gothy Bear is an ash grey colour with reddened eyes.

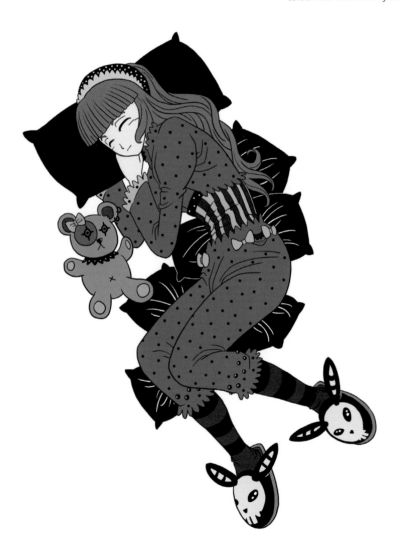

4. Lighting and Shading

The light source is in front of the
character. This increases the sense
of relaxation of the slumber and
accentuates her soft, angelic smile.
The lighting and shading of the
black cushions helps to clarify them.

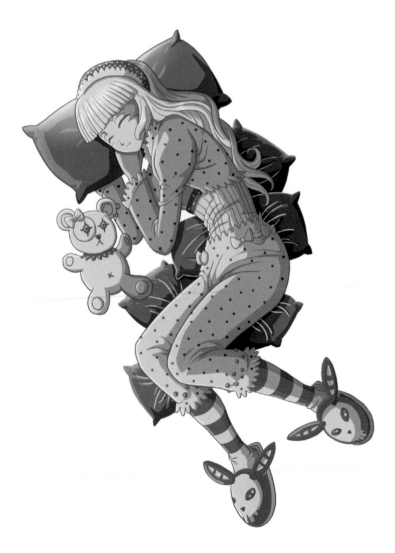

5. Finishing Touches

Finally, the areas of black have been toned down to a dark brown to give the illustration a greater sense of harmony. The bear is given a light shading of blue so that it matches Alice's long hair.

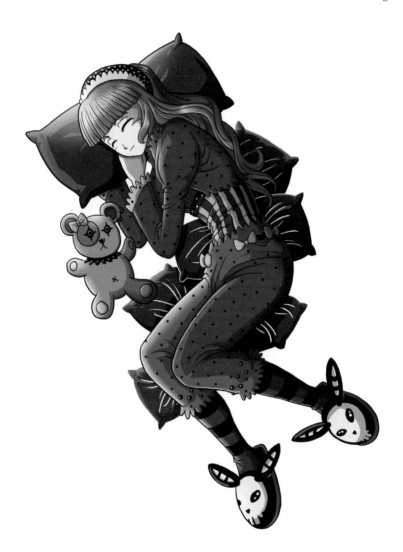

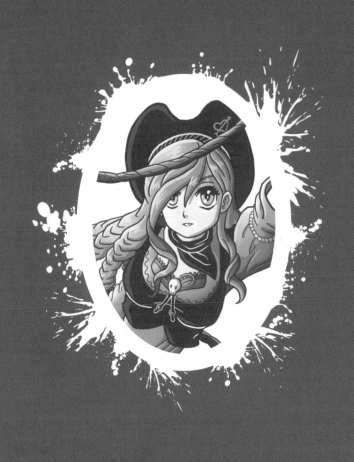

GOTHIC LOLITAS: PROFESSIONS

Gothic Lolitas wear their complex and interesting attire proudly. Their clothes reflect the sadness and profundity of their inner lives, and they have always had difficulty matching their tastes in style with the garb that they must wear to work. However, there is a revolution happening in the workplace, and the Gothic Lolitas use their imaginations to adapt and make their work clothing fit the Gothic style. What is more, they do all of this without detracting from the strength and character of the Gothic movement.

This chapter shows how characters from a range of professions, such as cartoonists (Chibi Oyura), rock stars (Moira McFalls), nurses (Dalia), soldiers (Lea Stands) or even cowgirls (Olivia Montana), adapt their work outfits to reflect their own personalities through the Gothic style. In every case, this does not conflict with the practicality or sensuality of their attire, and the originality of the designs means they are a sure success.

DALIA
GOTHIC NURSE

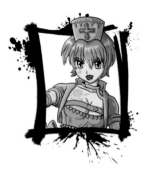

Although her outfit surprises patients when they first see it, Dalia is a caring and attentive nurse. Thanks to her pampering, those in her care recover quickly.

1. OUTLINE

Outline a character who is sure of herself, with both feet firmly on the ground and limbs stretched. Her hips are thrust forwards and sideways relative to the position of the head. She also offers us something in her right hand.

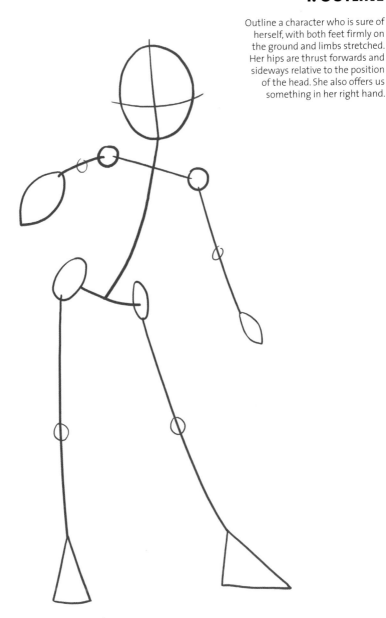

2. SKETCHING

Dalia has very rounded and curvaceous figure. You can show the character's style with the sketching, as in the case of the left foot, on which is added a high-heeled shoe.

3. PENCILLING

Detail the character's items and adornments: the nurse's cap with the cross, the short top, the rolled-up sleeves, the top, the gloves, the pill, the miniskirt, the stockings, the train and the shoes.

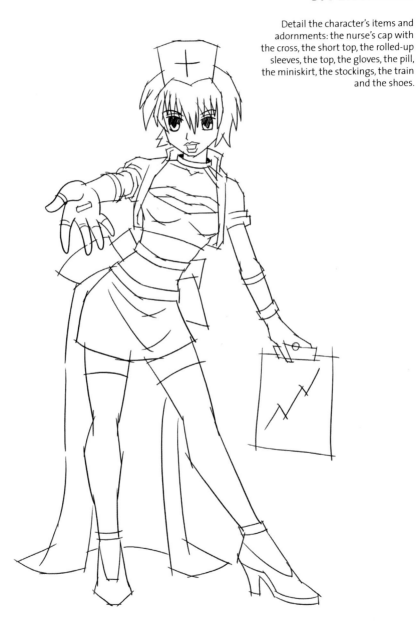

4. INKING

Add definition to each of these items, giving them the final appearance that you are looking for. Also add detail such as the lace trim, the adornments on the cap and stockings, and the creases of the clothing.

5. Layers of Colour

'Nurse green' is the main theme for our character's colour scheme. The blue hair, the pale pink skin and the red of the pill provide the necessary contrast.

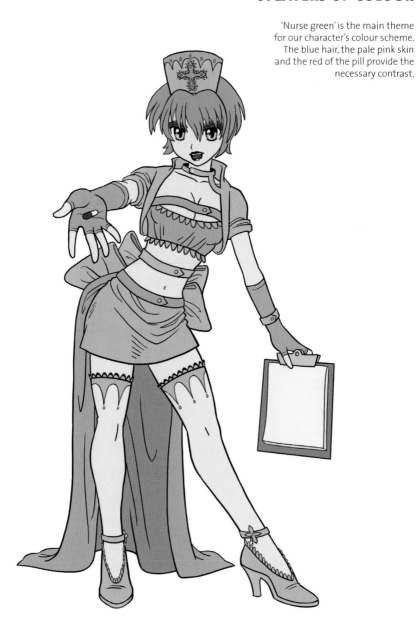

6. Lighting and Shading

The minimum layer of light (white of fifty per cent opacity), is applied, with the light coming from the left. This gives volume to the hair. The two more worked and developed layers of shadow give the figure volume.

7. FINISHING TOUCHES

To complete the drawing, add the tattoos and graphics. It is never too late to change one of the details. Here I have decided to change the hair to grey and to leave the stockings white.

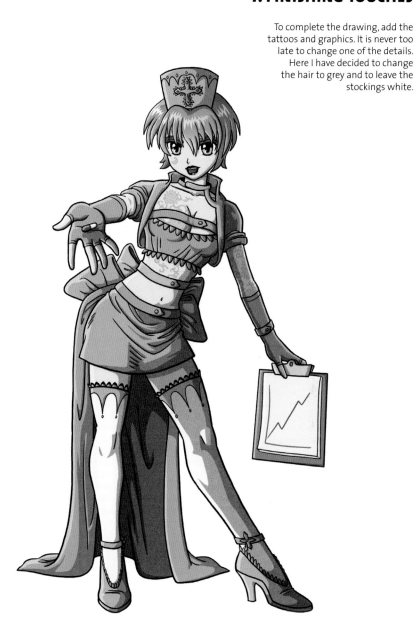

RIHANA
GOTHIC DANCER

Rihana is not your average ballet dancer. Through her dark style and agile and elegant movements, she expresses all of the strength, emotion and sadness of her Gothic world.

1. Outline and Sketching

Here I wish to show the classic ballet stance with the outline, on tip toe, with her limbs outstretched in an elegant pose.

2. PENCILLING AND INKING

Move on to the small details (such as the flower-straps on her back or the belt that is lifted up by the movement) after a few attempts at the pencilling. Improve upon these details by going over the bold pencilling with ink.

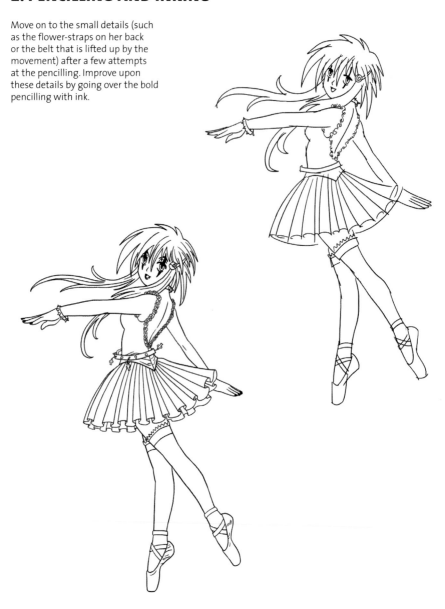

3. Layers of Colour

Rihana's sinister ballet costume is made up of dark blues and ash greys. The pink colour of her hair gives contrast and a touch of audacity and irreverence.

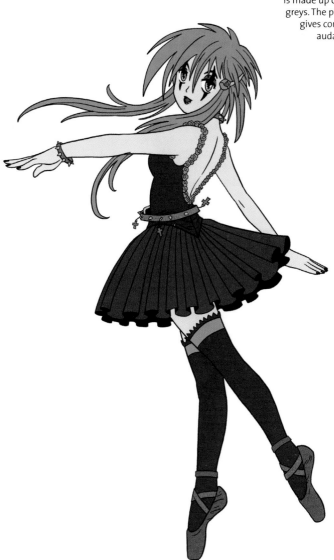

4. Lighting and Shading

Once more, the light, which comes from the left, does not impact much upon the image except for its effect on the hair. Two layers of shading give a volume that emphasises the figure's back.

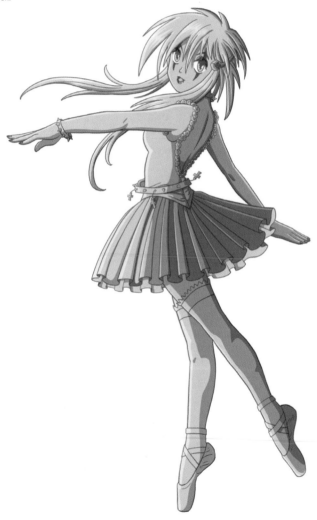

5. Finishing Touches

Add skull motifs to the tights and the body of the costume. Also apply light layers of different-coloured shading, for example to the hair, of light and darker pink.

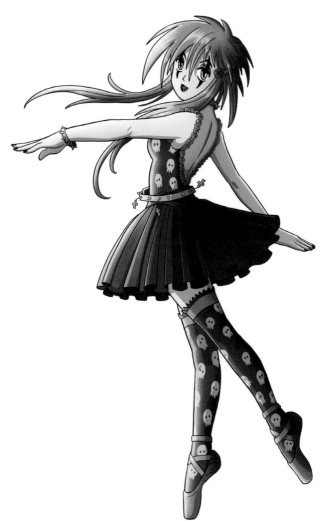

LEA STANDS
GOTHIC SOLDIER

Lea Stands is a hard and brave soldier, and can complete any mission just as well as the best man in the army. As such, she has everyone's respect, and nobody dares to argue with her Gothic style.

1. OUTLINE AND SKETCHING

The outline shows a figure running with one hand raised in salute. In the sketching stage, apply volume and a feminine shape to the figure: a developed chest, a narrow waist and wide hips.

2. Pencilling and Inking

The pencilling shows her hair flying behind her as she runs, and details the hood, the zips and the other aspects of her clothing. These elements are then defined with the inking stage.

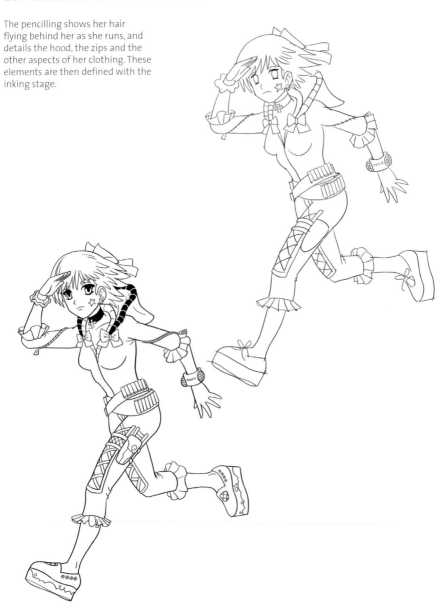

3. Layers of Colour

The military camouflage of the uniform contrasts with Lea Stands' turquoise hair and the inappropriate, violet-colored shoes. You can always add details that you forgot, like the stockings and the laces.

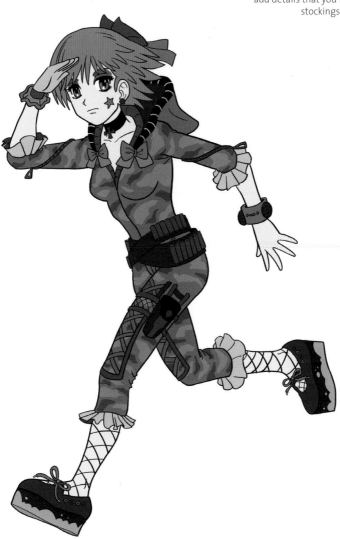

4. Lighting and Shading

The light is coming from in front of the character, to the viewer's left. As such, shadow is applied to the area behind the character, to the right, using two layers of twenty-five per cent superimposed black.

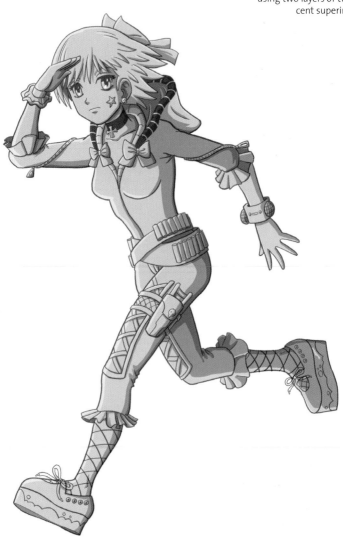

5. Finishing Touches

In this stage, add any detail that you feel necessary to enrich the illustration. In this case, apply red and violet Gothic cherry stamps to the uniform.

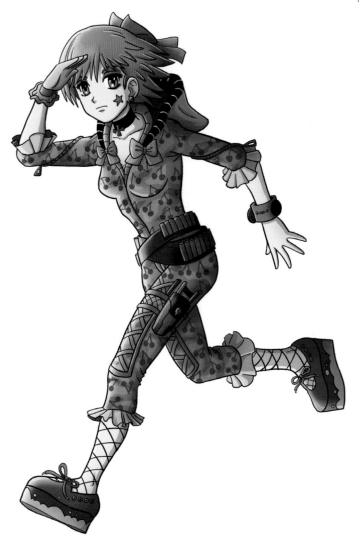

CHIBI OYURA
GOTHIC CARTOONIST

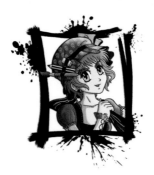

An illustrator must be included in a book on Gothic Lolitas. Chibi Oyura is the chosen pseudonym for this young cartoonist, who loves both manga and the Gothic style.

1. Outline and Sketching

Outline the figure standing, with one arm and one leg bent, while the other leg and other arm remain outstretched. Give volume to the outline with the sketching.

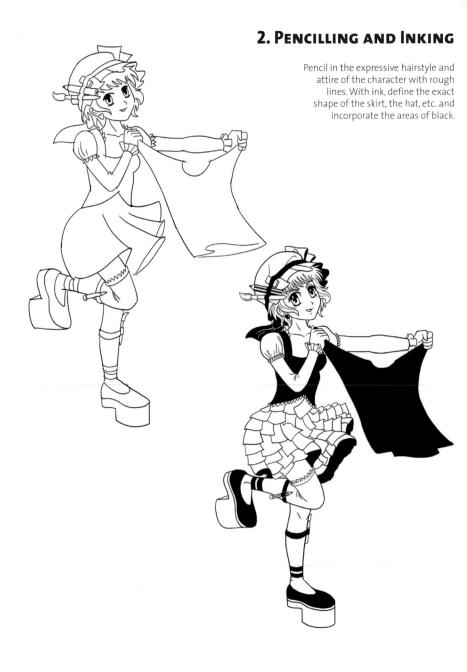

2. PENCILLING AND INKING

Pencil in the expressive hairstyle and attire of the character with rough lines. With ink, define the exact shape of the skirt, the hat, etc. and incorporate the areas of black.

3. LAYERS OF COLOUR

The clothing is defined by the different tones of violet and finished off by some green detail. The orange of the hair and the yellow of the pencils provide contrast. The skin is of a pale pink colour.

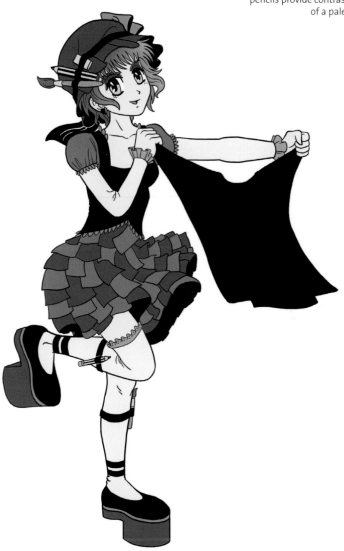

4. Lighting and Shading

Apply a single layer of shading to highlight the character's shape, with the light coming from the viewer's right. The two layers of shading on the left-hand side give volume and enrich the drawing.

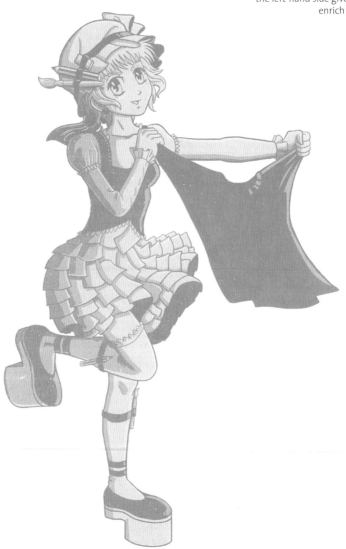

5. Finishing Touches

Finish off the illustration with the application of skulls to the hat and soles of the shoes. Also add white lines and a logo to the black parts of the shoes and the T-shirt.

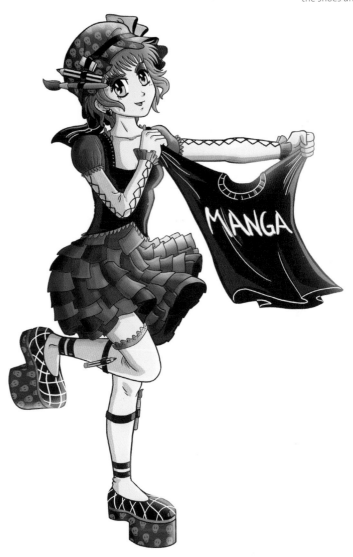

Moira McFalls
Gothic Rock Star

Moira McFalls is a Gothic rock superstar and a trendsetter with her music, her hairstyles and her dress-sense. She is the idol of millions of fans for her virtuoso guitar playing.

1. Outline and Sketching

Outline a kneeling figure, with her
head turned towards the viewer,
holding up a Flying V guitar. Give
the feminine figure and the guitar
volume by sketching.

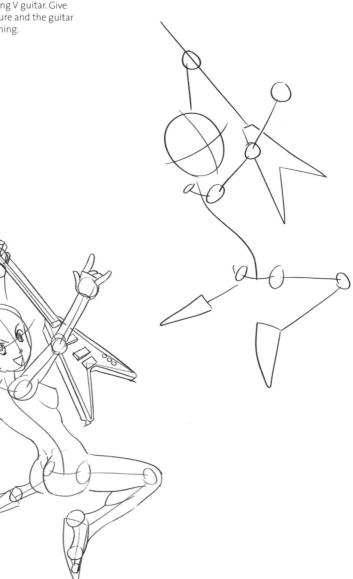

2. PENCILLING AND INKING

The pencilling stage will be when you show all of the elements that will make up the illustration. The inking gives each of these elements definition, detailing even the smallest ones. You will also fill in the areas of black.

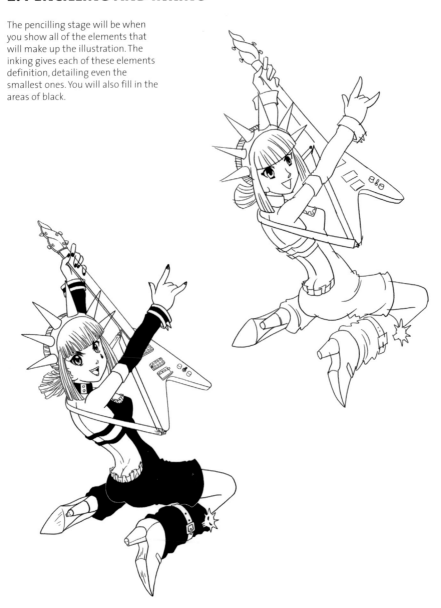

3. Layers of Colour

This character bases her costume on the famous Statue of Liberty. The dominant colour is therefore the green of the statue. The colours of the guitar's head represent the torch the statue carries in her right hand.

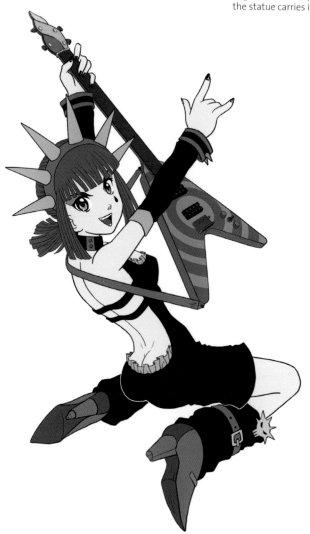

4. LIGHTING AND SHADING

The lighting and shading skip over the hair, the clothing, the spikes on the girl's head, and the head of the guitar, as though the figure is being illuminated by light from different directions during a concert.

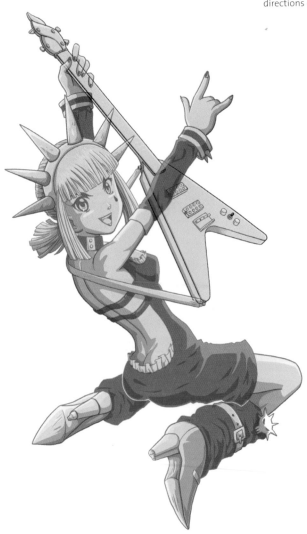

5. Finishing Touches

Leave the frets of the neck and the guitar strings until the end, along with the white lines on the girl's black clothing and boots. The final touch is the floral tattoo on Moira's shoulder.

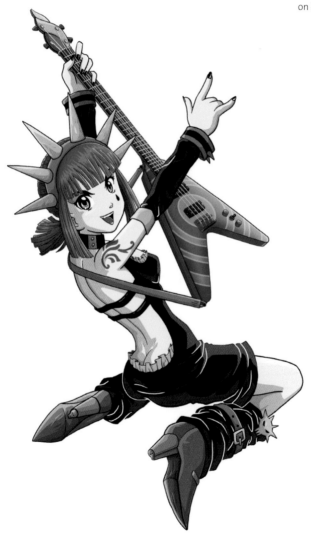

OLIVIA
MONTANA
GOTHIC COWGIRL

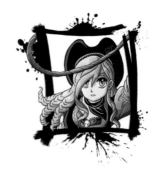

Olivia Montana is a famous cowgirl, and is the lasso champion. She has broken all the records at the rodeo festivals she attends, without compromising her beauty and her beloved Gothic style.

1. OUTLINE AND SKETCHING

Outline the character, seen from a high angle, swinging a lasso. The sketching allows you to emphasise the perspective and define the volume of the character.

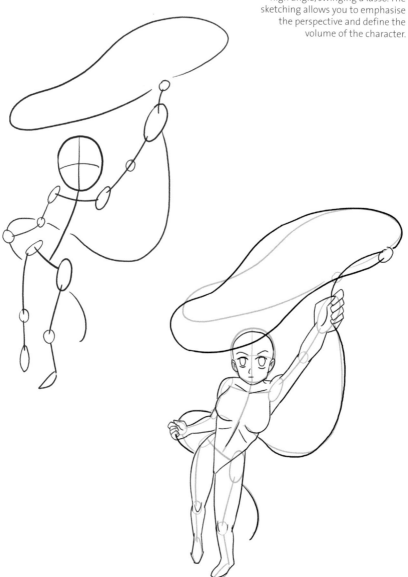

2. PENCILLING AND INKING

Using a pencil, sketch the hairstyle, the outfit and the thickness of the lasso, then further define these elements with the ink. Add more detail, such as the skirt patterning, the rope and the hair, and add the areas of black.

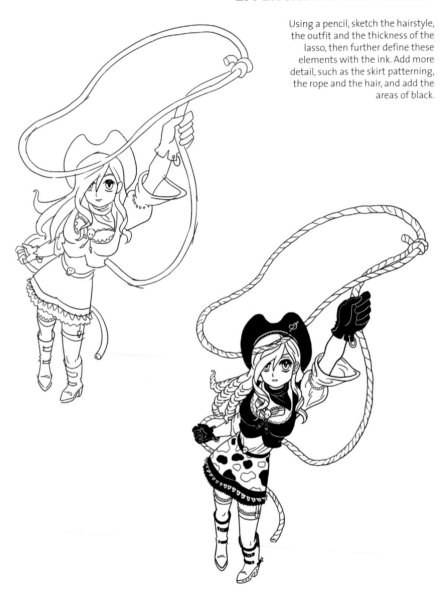

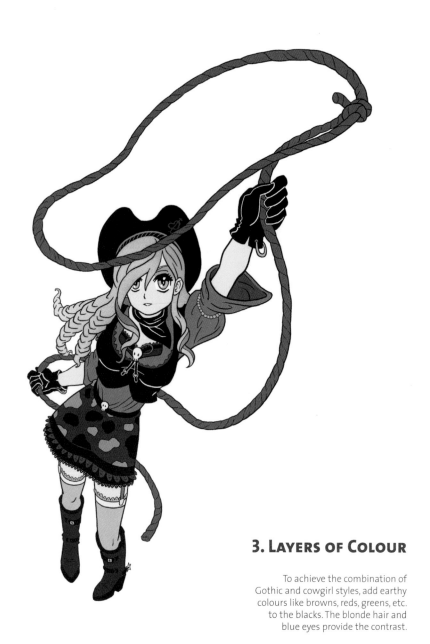

3. LAYERS OF COLOUR

To achieve the combination of
Gothic and cowgirl styles, add earthy
colours like browns, reds, greens, etc.
to the blacks. The blonde hair and
blue eyes provide the contrast.

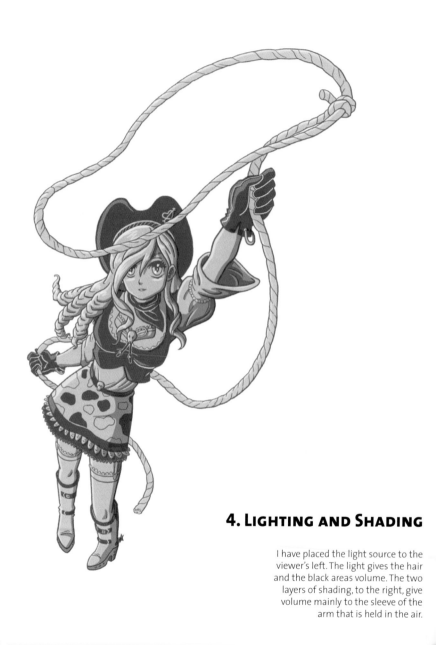

4. LIGHTING AND SHADING

I have placed the light source to the viewer's left. The light gives the hair and the black areas volume. The two layers of shading, to the right, give volume mainly to the sleeve of the arm that is held in the air.

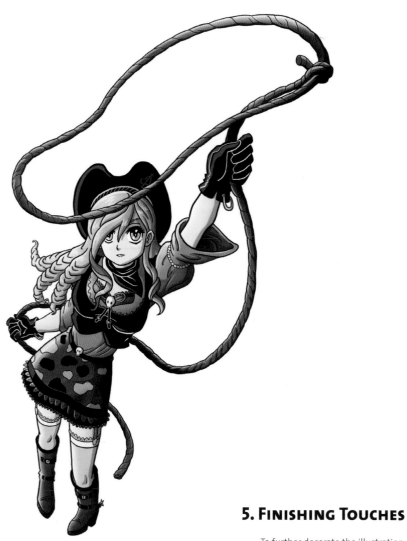

5. Finishing Touches

To further decorate the illustration, apply light shades to each of the colours. Also add some further shading to the twirling lasso.

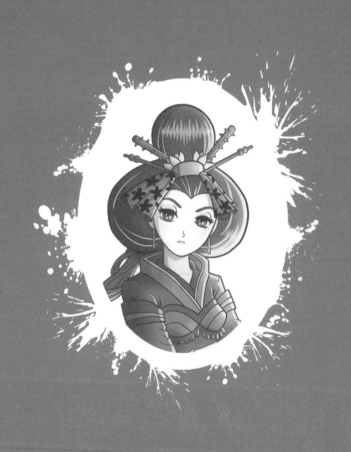

GOTHIC LOLITAS: PAST AND FUTURE

The modern-day Gothic Lolita style is an iconic and perfectly recognisable style that is separate from the rest of the Lolitas. It originated with the revamping of costumes that were worn in the Victorian age, at the beginning of the nineteenth century (Margaret Swan). However, the tortured struggle of the young to define themselves, express themselves freely and portray the profundity of their inner lives has always been there, and always will be.

The Gothic style has been around since long before the Victorian age, from the anonymous Gothic geishas (Madame Solittude) to the queens of the most infamous empires (Elizabeth Black). Those early Lolitas were unaware that their style would form part of the history of a movement born centuries later, which would go on through time and space, to other planets and other non-human races (Antharst II). The untold story of the Gothic Lolitas is exciting, and its future profoundly dark.

ELIZABETH BLACK
GOTHIC QUEEN

This famous queen of England made a powerful start to her reign, adopting a dark and Gothic style. Great artists like the writer William Shakespeare thrived during her reign.

1. Outline

The feet are planted firmly on the ground. Although they will not be seen in the final drawing, this helps you to correctly position the figure and give her an upright, proud, serene and powerful stance.

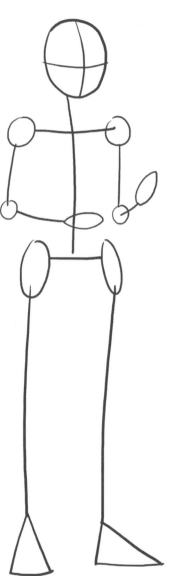

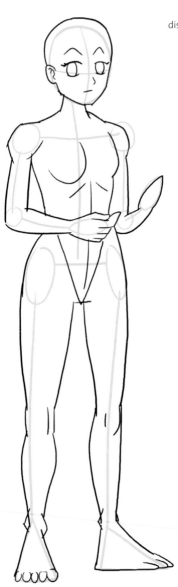

2. SKETCHING

Sketch the naked frame of the queen, making the legs disproportionately large, so that you can later add the enormous dress that covers them.

3. PENCILLING

Here, you define the dress with the folds of the skirt, the bodice and the ruff. Add the hairstyle, the staff and some royal jewellery.

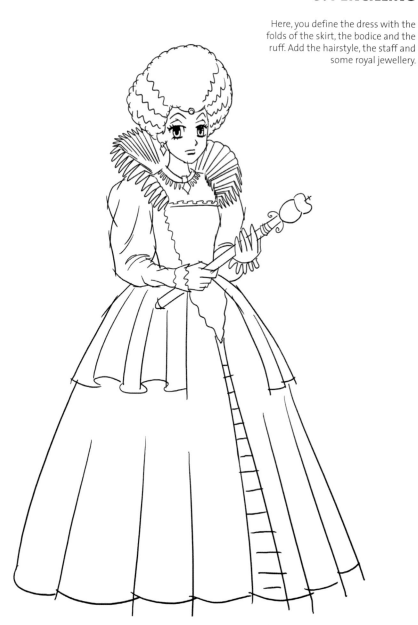

4. INKING

Add further detail to the elements of the clothing and the accessories: embroidery, adornment, jewellery, etc. Define the folds of the skirt, making it appear that the folds continue round to the rear.

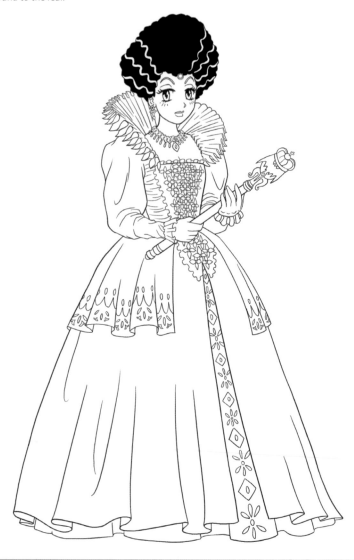

5. LAYERS OF COLOUR

Grey is the predominant colour here, with dark and luxurious touches of gold for the details. The white embroidery stands out from the grey areas. The lips match the dress, as does the eye shadow.

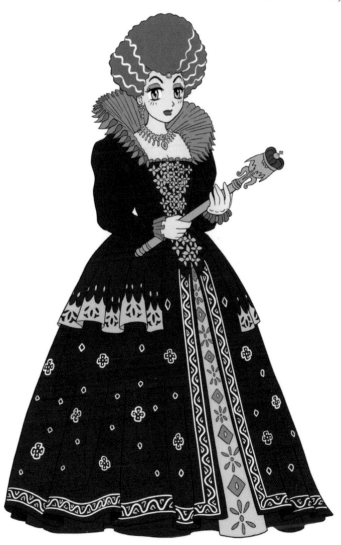

6. Lighting and Shading

The light is coming from the right.
It is important to emphasise
the shading on the folds of the
clothing to make the volume more
realistic. To achieve this, apply
three layers of shading.

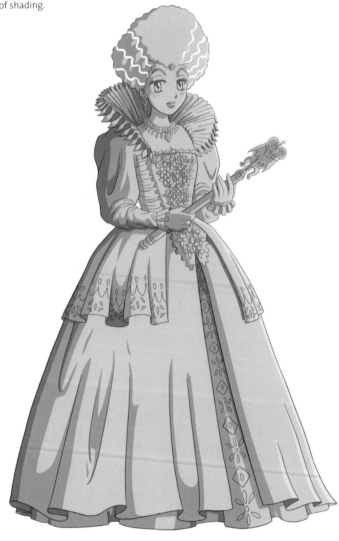

7. FINISHING TOUCHES

Apply more light to the dress in the form of a blurred sheen, to blend with the overall shading. This gives an even statelier and slightly melancholic feel.

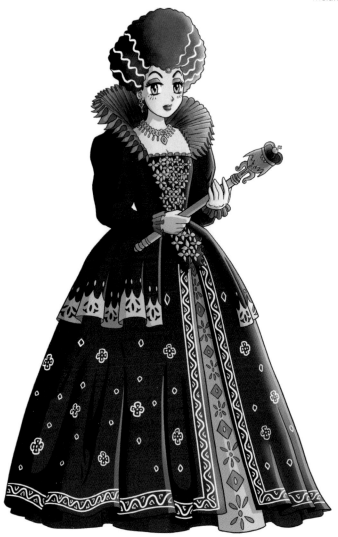

MADAME
SOLITTUDE
GOTHIC GEISHA

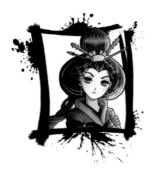

Behind the timid countenance of this young geisha hides a wise woman with great inner strength. She has had to grow up quickly to deal with the hard times through which she has lived.

1. Outline and Sketching

Her feet are planted firmly on the ground, her hips twisted and her back curved slightly; all signs of an upright body in the resting position. The position of her staff is also established.

2. PENCILLING AND INKING

In the pencilling stage you fill out the volume of the clothing and outline the staff. In the inking stage you draw the ponytail, go over the fall and creases of the dress, and add detail to all of the other features and accessories.

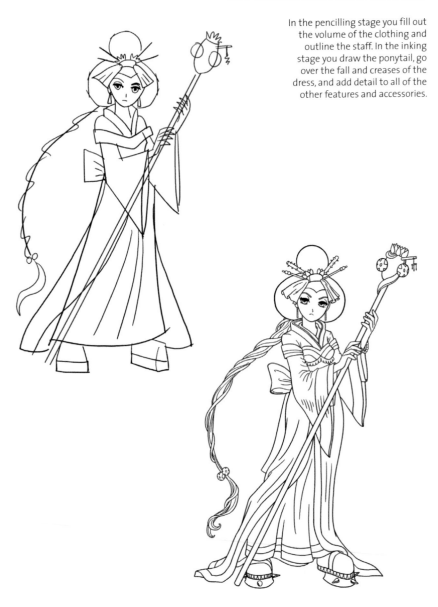

3. LAYERS OF COLOUR

Grey and maroon are the
fundamental colours of the dress.
The dark hair contrasts with the
face's pale make-up. The gold details
provide contrast. I have also added
detail to the head bow.

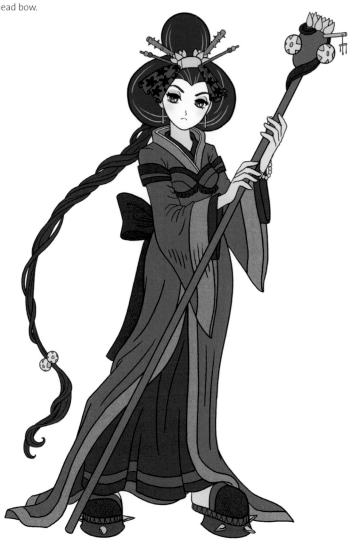

4. Lighting and Shading

The light gives the hair volume. The two layers of shading give volume to the dress. The bow on the geisha's back and the inner lining of the robe are the darkest areas of the picture.

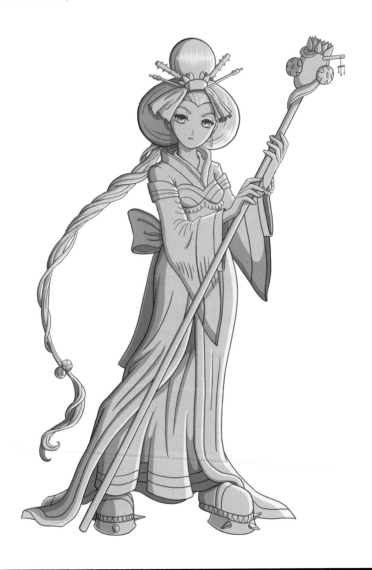

5. Finishing Touches

To finish, enrich the picture with little shades of light. This gives the character a more heretical look and gives more depth to the larger areas of colour, preventing the figure from appearing flat.

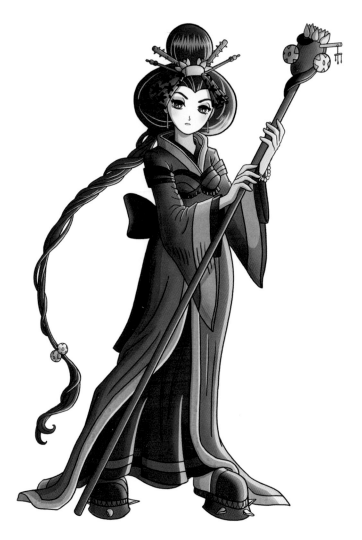

MARGARET
SWAN
GOTHIC LADY

The Gothic Lady sadly awaits the return of her beloved. We can tell from her red curls and the green detail on her dress that she comes from a noble Scottish family.

1. Outline and Sketching

The figure's shyness and sadness are portrayed through her posture: leaning on her umbrella, her knees together, her shoulders pushed back, her hand near to her cheek, and her head bowed.

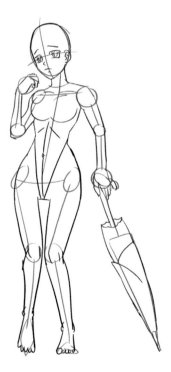

2. PENCILLING AND INKING

Sketch the hat, the hairstyle, the
dress and the umbrella. With
the final inking, define and add
detail to the various elements,
paying particular attention to
the folds of the dress, which
indicate movement.

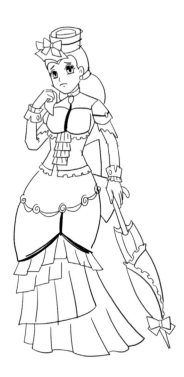

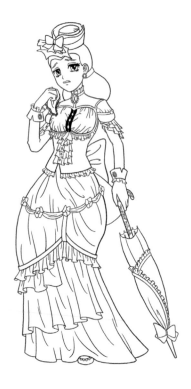

3. Layers of Colour

With the grey and purple we achieve a sombre look without using black, which we use only for specific details. The red hair and the areas of green give contrast.

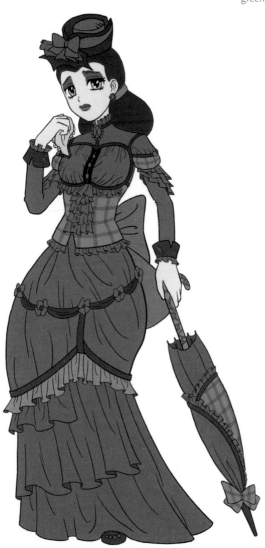

4. Lighting and Shading

The light is coming from the left and the appropriate shading is added to the right, particularly to the folds. The shading heightens the idea of volume and movement.

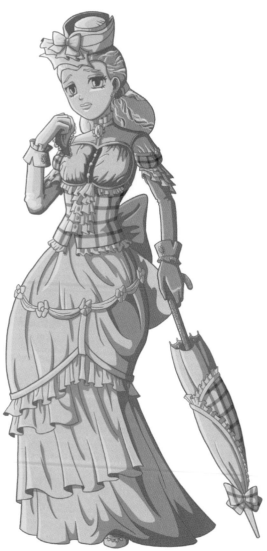

5. Finishing Touches

To finish off the drawing, add a floral design to the areas of violet and a tartan design to the areas of green. Finally, a characteristic widow's veil and train complete the ensemble.

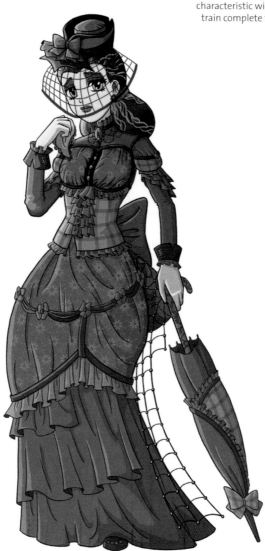

ANTHARST II
GOTHIC ALIEN

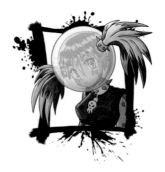

We travel forward to the year 5025. This young alien girl comes from some distant planet outside our galaxy. Despite this, she cannot get enough of this interstellar Gothic style.

1. Outline and Sketching

Outline and sketch another shy figure. Once again, her head is bowed, her spine curved and her feet are pointing inwards. One hand is held in the other, and they are hidden behind her back.

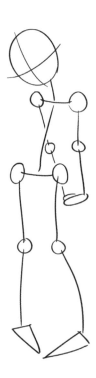

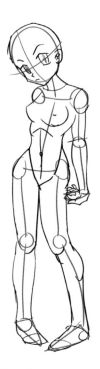

2. Pencilling and Inking

In the pencilling stage, draw the general features: the large pigtails, the choker necklace, the dress, the boots, etc. In the inking stage, detail and highlight the spots on the skin and the different areas on the hair, and put in the black areas.

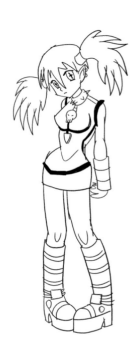

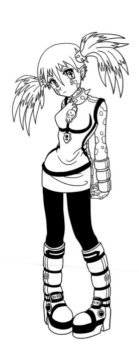

3. Colour

Use highly contrasting, strong and non-human colours for the skin and the hair. At the same time, use colours that are very different from one another to differentiate the clothing from the wrist cuffs and the boots.

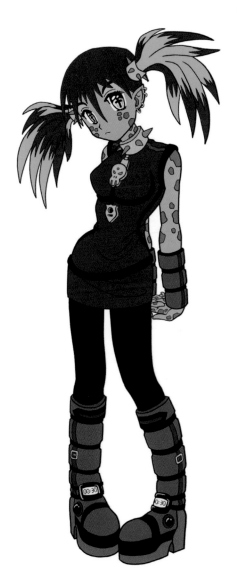

4. Lighting and Shading

Using light, you give the figure
volume, and give texture to the
skin. The shading also helps you to
emphasise the folds in the clothes,
and the accessories.

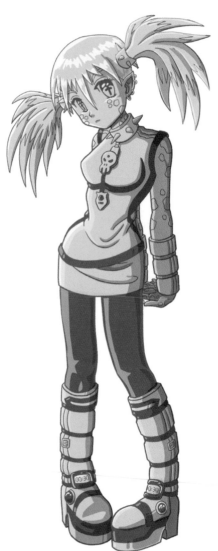

5. Finishing Touches

For the final touches, add the glass ball to the head, which highlights the alien nature of our character, and give the clothing a bizarre pattern.

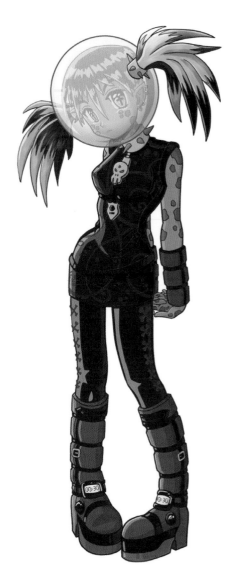

CAPTAIN
DARKCHILD
GOTHIC SPACE PIRATE

Our pirate space captain has a vibrant personality
and is full of vitality, ready to fight to the end for
treasure that she might find on a distant planet.

1. Outline and Sketching

The outline is of a character that is moving, with her limbs flexed, brandishing a sword. You then sketch the closed fist, the pointed ears and her powerful legs.

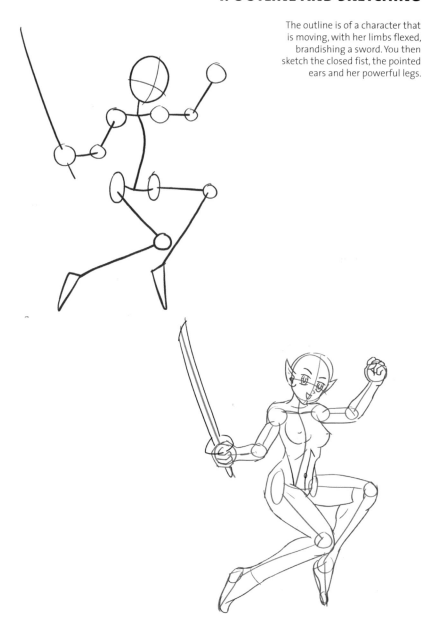

2. Pencilling and Inking

Pencil in the detail on the
character's clothing, along with
the sword and the treasure map.
Improve upon each of these
elements' details in the inking
stage, and put in the black areas
and the folds of the material.

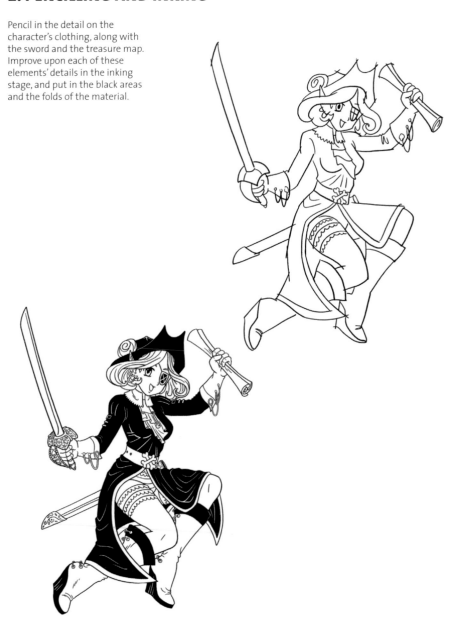

3. Layers of Colour

A combination of reds and blacks differentiates the various parts of the outfit. The gold gives contrast, and the green hair has a definite alien feel.

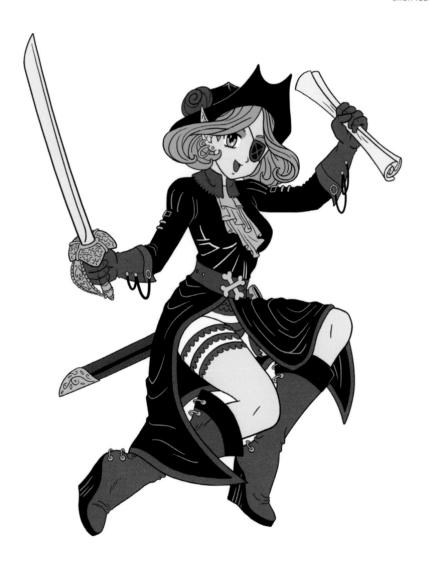

4. Lighting and Shading

The light source is in front of this character. Here, with such a large amount of black, well-placed shading improves the drawing.

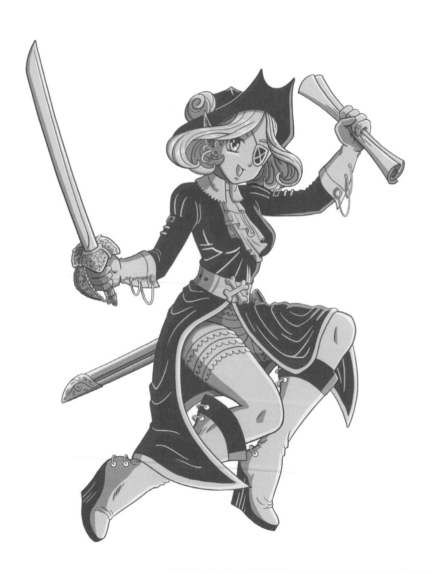

5. Finishing Touches

The final detail, to further enrich the drawing, is the floral design that has been incorporated into the black areas of the clothing. Although it is of low opacity, it serves its purpose perfectly.

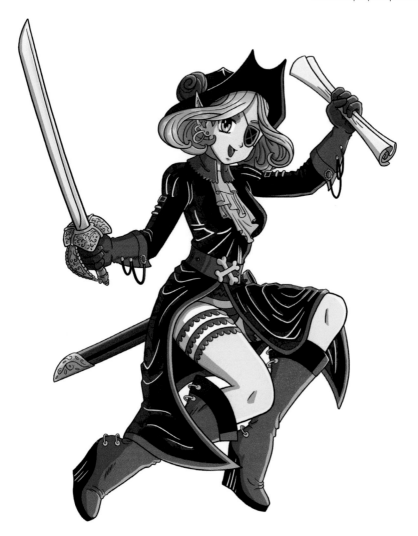

MARLENE BLUE
GOTHIC BRIDE

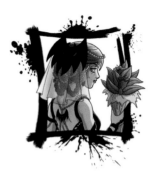

The Gothic bride is a much-used icon, and she sports a strange mix of almost opposing accessories. In this case they signify the strongly romantic nature of our Gothic bride.

1. OUTLINE AND SKETCHING

Outline and sketch a character walking slowly towards the altar. Her left arm falls gently and her right hand holds a Gothic bouquet.

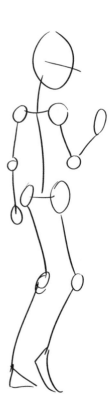

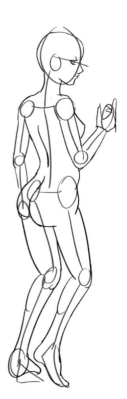

2. Pencilling and Inking

In the pencilling stage you see the clear definition of the different elements that make up the dress and the accessories. A fine ink and well-placed areas of black bring them all to life.

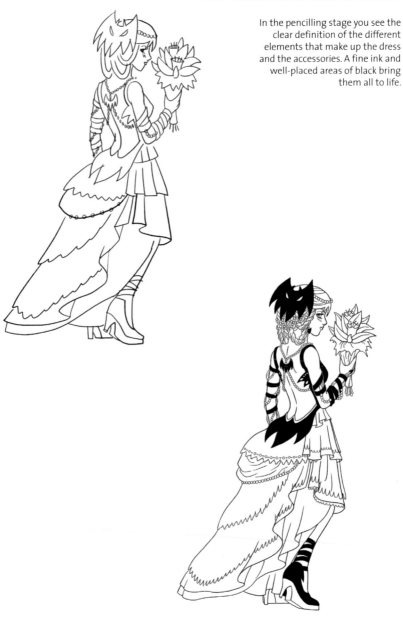

3. Layers of Colour

The dark colours of the skirt allow the bride to retain her Gothic style. The fact that the dress is backless shows she is also an exhibitionist. Lastly, the bride's hair and bouquet provide contrast.

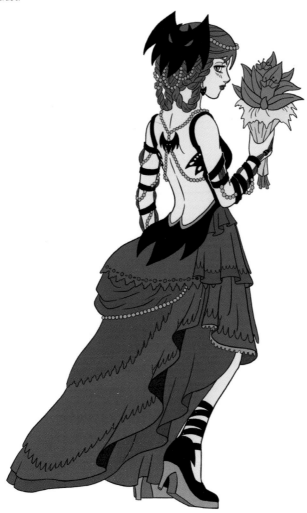

4. Lighting and Shading

In this case, the light comes from the altar towards which the bride is walking. Detailed shading on the complex dress helps to show movement and prevents the figure from seeming static.

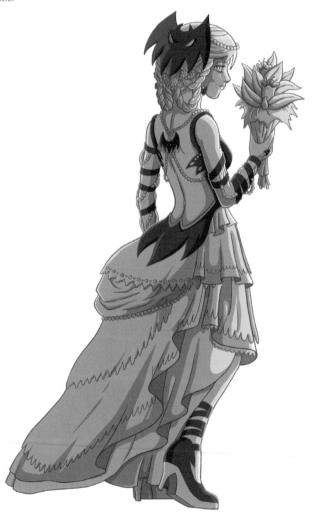

5. Finishing Touches

Apply further detail to the finished drawing. In this case, add the netting to areas of the dress and the bride's veil. Give the veil enough transparency that you can see the detail of the hairstyle underneath.

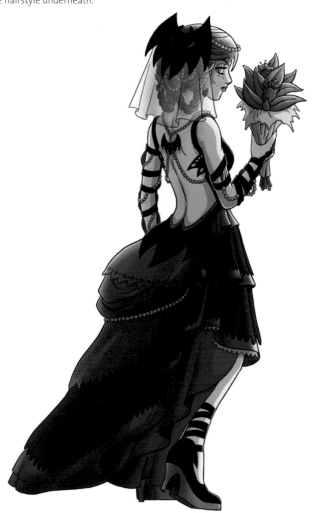

GOTHIC LOLITAS: MYTHS AND LEGENDS

A great many fantasy beings populate the myths and legends that capture and enchant our imaginations. Among these beings are adolescent females who possess a natural or supernatural power and an irresistible attraction. In this chapter we see witches (Dula Honwacker), sirens (Nereheida), vampires (Nosferatta) and other powerful and fantastical Lolitas, who fit perfectly into the Gothic style.

By dressing the characters in these sinister outfits, well-known characters who have been used countless times before are given a new twist and a modern, unique style. This helps to give two sides to our characters at the same time: on one hand they show tenderness, but on the other, they retain an aura of mystery and danger, which fills us with a deep mistrust.

DULA HONWACKER
GOTHIC WITCH

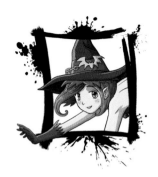

Dula Honwacker is a magnificent sorceress capable of performing highly complex spells and innumerable curses. However, she still has not quite mastered flying on her magic broomstick.

1. Outline

The outline shows a figure being dragged along, out of control. With her back curved and her legs bent acrobatically, the character can only hold on to the flying broom with her left hand.

2. Sketching

The character is viewed more or less from behind, except for her head, which is lifted towards the viewer. One hand is closed around the broom, the other attempts to control her flight.

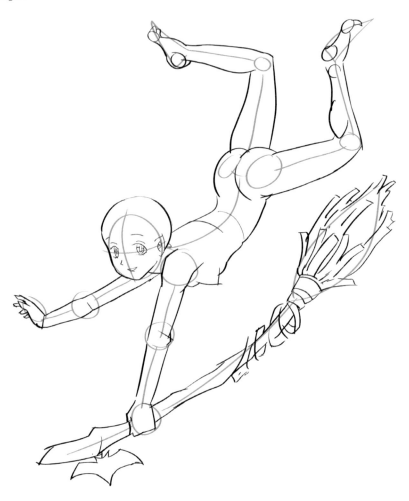

3. PENCILLING

The creased hat with the bat symbol, the strange hairstyle, the long gloves, the striped stockings and the pointed boots all add to the character's personality.

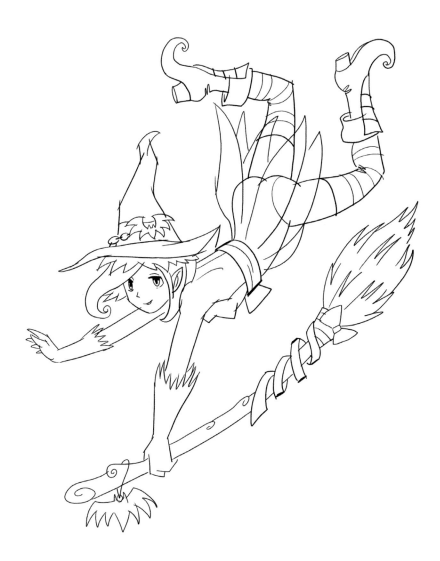

4. INKING

Here all of the elements that we drew in the pencilling stage are refined. The broom has a personality of its own, with detailing on the handle, a pretty bow and a bat key ring hanging from the end.

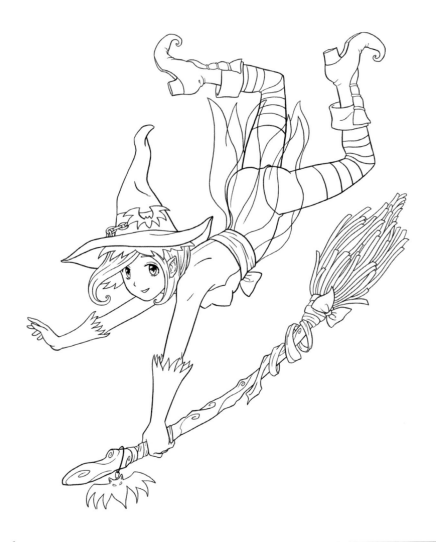

5. Lighting and Shading

The light is coming from the sun above, so the light is applied to the upper part of the girl. The shadow, spread over two semi-transparent layers and located on the lower part, give volume and consistency to the figure.

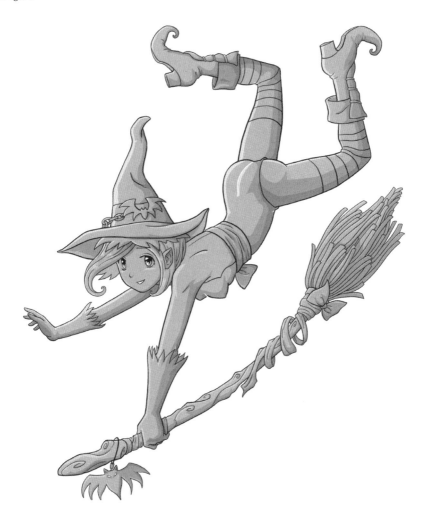

6. Layers of Colour

Combine earthy tones for the
clothing with greens for her hair,
skirt and costume. The broom
follows the same colour scheme.
The yellows and ochres of the brush
balance the gold of the bats on her
hat and broom handle.

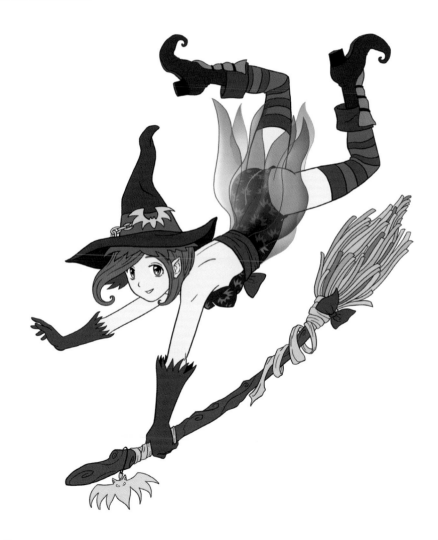

7. Finishing Touches

I have added details such as the eye shadow and green freckles to go with the character's colour scheme. The transparency of the skirt adds a sense of lightness to the ensemble.

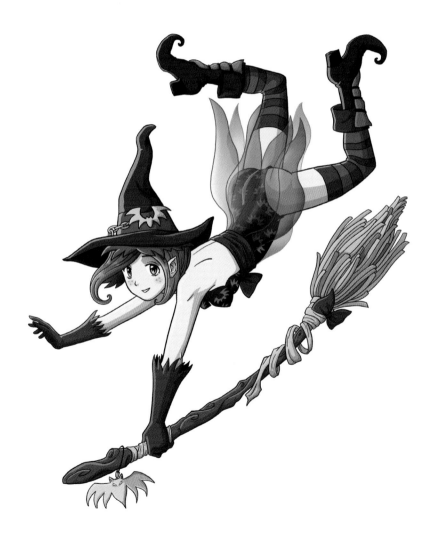

LADY TURNA
GOTHIC SPACE QUEEN

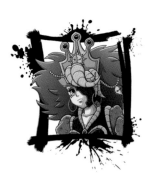

Lady Turna is the proud ruler of the second quadrant of the Orion galaxy. Her cruelty is matched only by her madness, and as such you do not disobey her orders, or she has your head cut off.

1. OUTLINE AND SKETCHING

Even in the sketching stage, you can see the solid posture signifying the queen's haughty personality. She regards us as though we were meaningless insects.

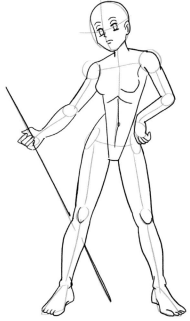

2. Pencilling

The monarch is adorned with complex and outrageous elements, such as the spiked sceptre the real fur cape, the lion's mane and the spectacular crown that holds her mask in place.

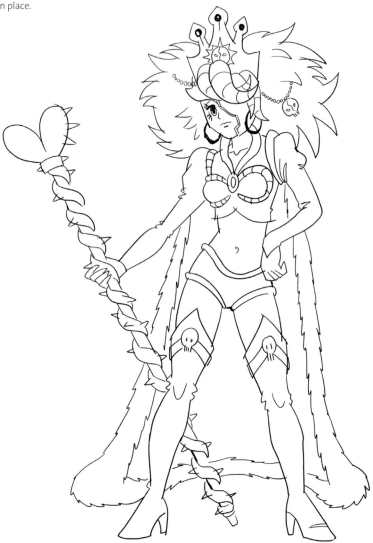

3. Inking and Layers of Colour

Apply a combination of straight and curved lines of ink. The colouring is outlandish and disparate: purples and turquoises for the suit and golds and reds for the royal accessories.

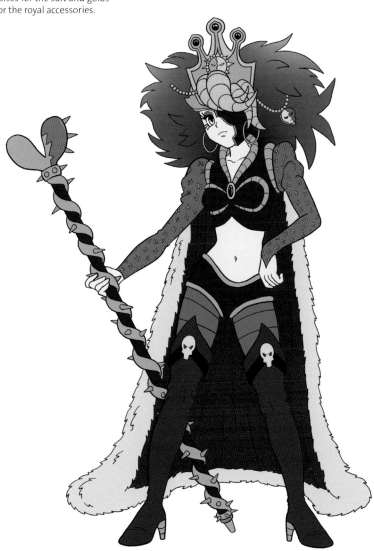

4. Lighting and Shading

The light is coming from the left. To add depth to her cape, apply two layers of shading, one general layer from top to bottom and the other behind her back.

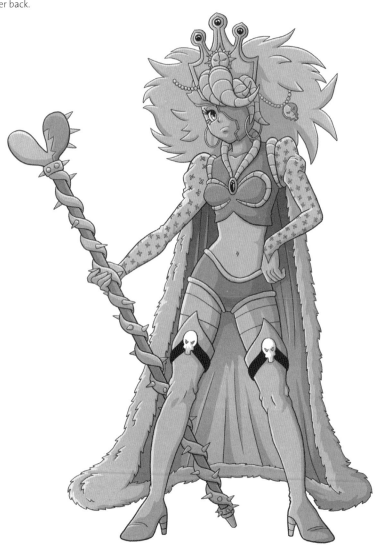

5. Finishing Touches

To reflect the character's imbalanced personality, I have changed the colour of the pants and one of the boots. The twists and spikes of the sceptre achieve a truly chaotic feel.

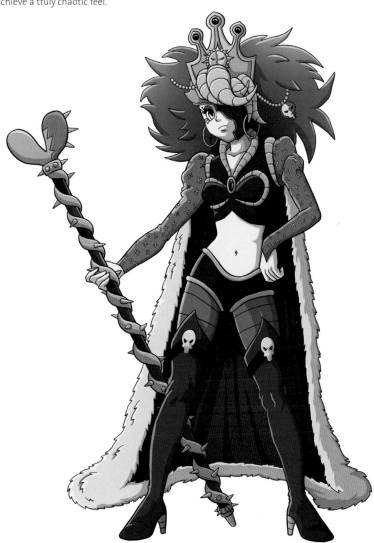

RED FOXXY
GOTHIC VIXEN

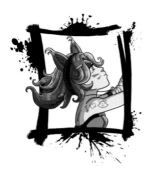

Red Foxxy is an animal lover, and she carefully nurtures and dotes upon all creatures. Indeed, she herself is half human and half fox, and has the eyesight and acute sense of smell of this skilled and cunning animal.

1. Outline and Sketching

Outline the character in profile, holding her pet up high. The sketching follows the curves of the legs and back traced in the outline. If you are feeling inspired, you can even draw the pet's body.

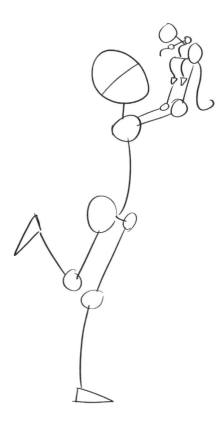

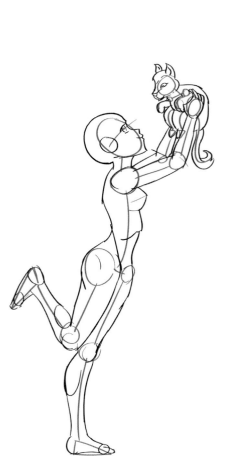

2. PENCILLING

Try to differentiate between the
human and animal parts, so use
fairly straight lines for the body and
very curved lines for the hair and
the tail.

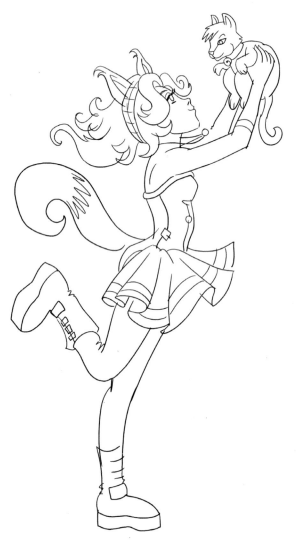

. INKING AND LAYERS OF COLOUR

the inking stage you detail the
ess and the boots. The colouring is
entred on tones of purple and violet
or the human part and auburn for
e animal part. Add fun tattoos.

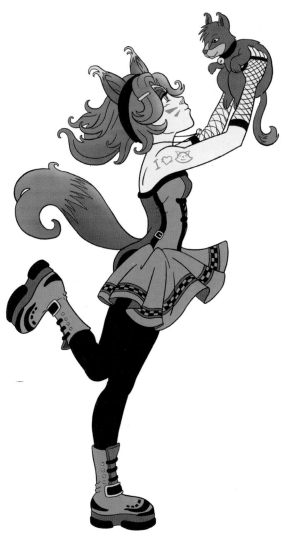

4. Lighting and Shading

The light is coming from the right.
More light, and two layers of
detailed shading, are added to the
hair to emphasise its shine and
attractiveness.

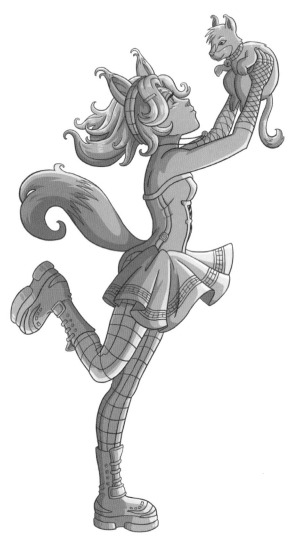

5. Finishing Touches

To finish, I have countered the weight of the lower part of the drawing by lightening the colours on the stockings. This leaves the illustration more balanced.

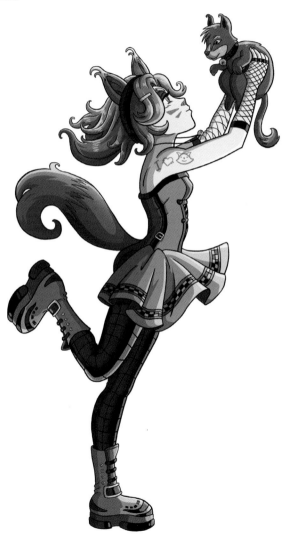

SATANGELA
GOTHIC SATANIC ANGEL

According to some legends, good and bad are part of the same thing, and forever maintain a balance. This duality is made clear in this Gothic Lolita with an angelic appearance and a demonic soul.

1. Outline and Sketching

The figure hovers in the air, her arms and legs bent. Add the halo, the wings and the tail. Apply volume in the sketching stage, along with the rest of the character's body.

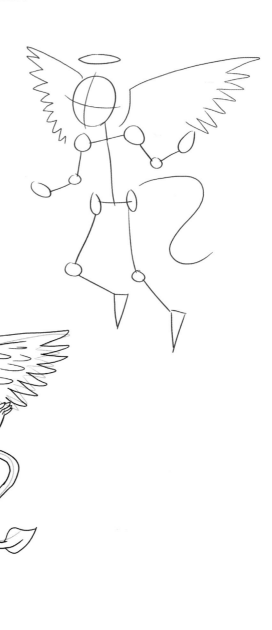

2. Pencilling

Incorporate all of the elements that give the figure her character. Draw the horns, which are lightly covered by the hair, and draw inner feathers on to the wings.

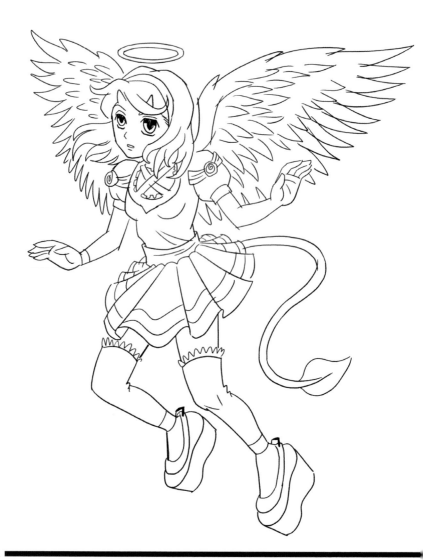

3. INKING AND LAYERS OF COLOUR

Highly detailed pencilling helps the
inking stage. The lower part of the
character is predominantly red and dark
colours. Light colours and celestial blue
are used for the upper part.

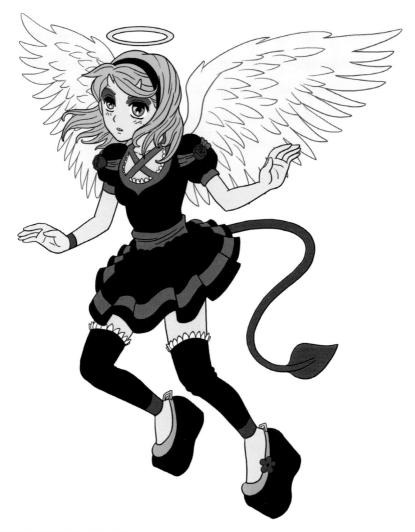

4. Lighting and Shading

The light comes from a celestial source. The two layers of shading define the volume and help to differentiate the texture of the wings and the tail.

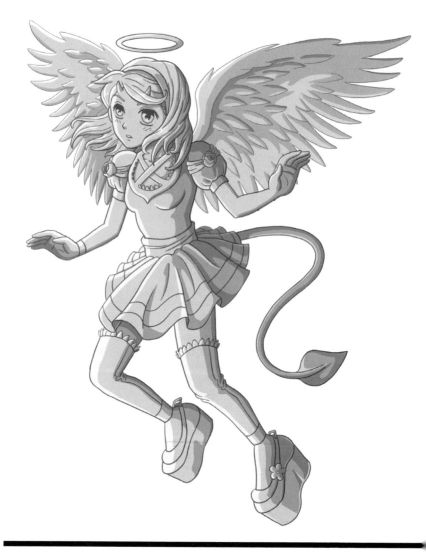

5. Finishing Touches

Complete the drawing by applying floral details to the dress. A touch of blusher to her cheeks shows the character's innocent side. The shading give greater volume and luminosity.

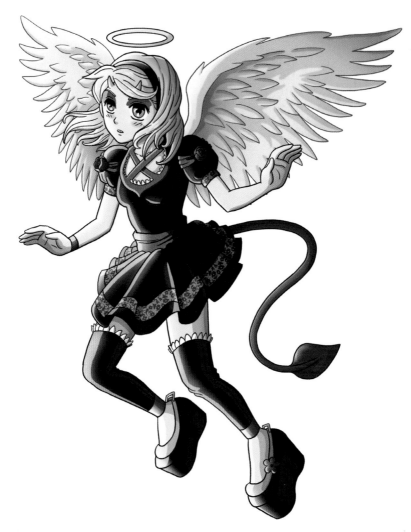

KEMEIKA
GOTHIC GHOST

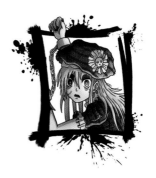

Kemeika is the ghost of a young Scottish girl who was drowned in a dark lake deep in the mountains by her wicked stepmother. Wearing her chains, she forever tries to climb the walls of her castle.

1. OUTLINE AND SKETCHING

Outline the posture with the hips pushed back and the arms resting on the wall. The sketching alone reveals the character's ghostliness, reflected in her terrifying gaze.

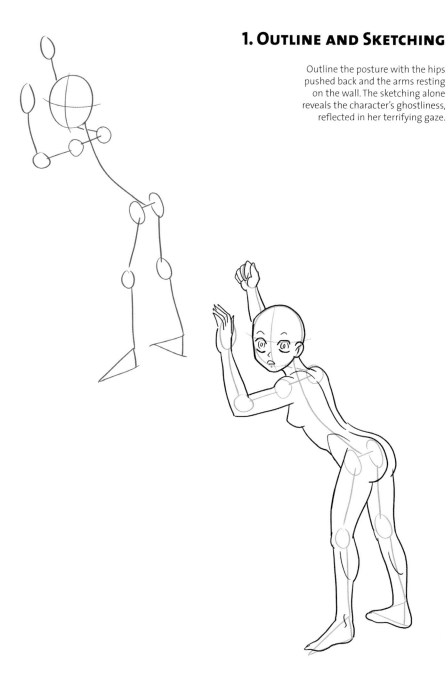

2. PENCILLING

Kemeika wears tattered rags and her hair is untidy. The manacles on her wrists and ankles, the pendant hanging from her belt, and the hat's motif further the sense of gloom.

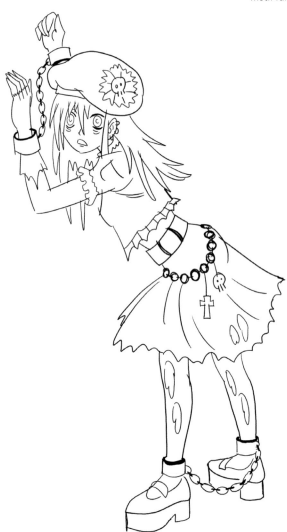

3. Inking and Layers of Colour

The inking is rough, in particular when drawing the tattered clothing. The dress has a red colour and the gloves and stockings are of a greyish-green. The blue hair provides contrast and gives a sense of coldness to the character.

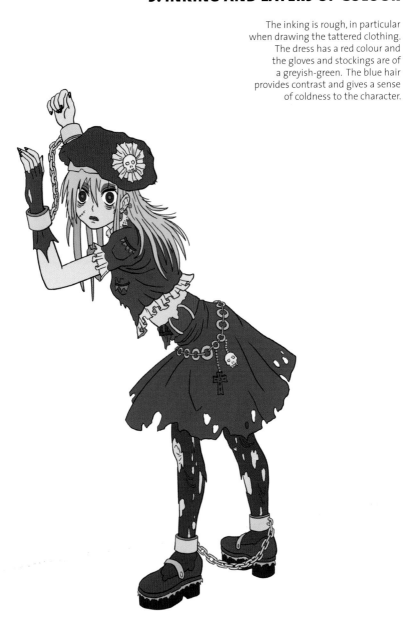

4. Lighting and Shading

The light hits the character's back, which heightens the unsettling quality of the illustration, leaving the face in shadow.

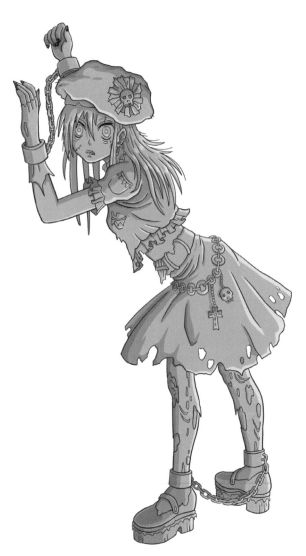

5. Finishing Touches

Add vertical and horizontal lines to the costume to make it very definitely tartan. Also apply a general, faint light to give a more ghostly feel.

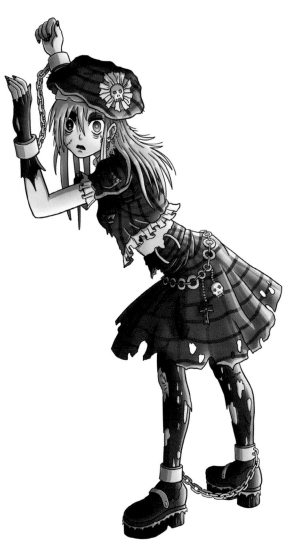

NEREHEIDA
GOTHIC SIREN

Although she retains her youthful appearance, Nereheida is one of the seven immortal sirens. She is recognised by her long white hair, and she crosses the oceans trying to attract sailors with her hypnotic singing.

1. Outline and Sketching

The outline shows the dynamic fishtail and the position of the arms stretched out behind the figure. In the sketching stage, you apply volume and position the head, chest and large tail.

2. Pencilling

Emphasise the undulating movement of the hair and the belt wound around the tail. Adorn the figure with bracelets, armlets, pearls and a large bow. Her chest is covered by two starfish.

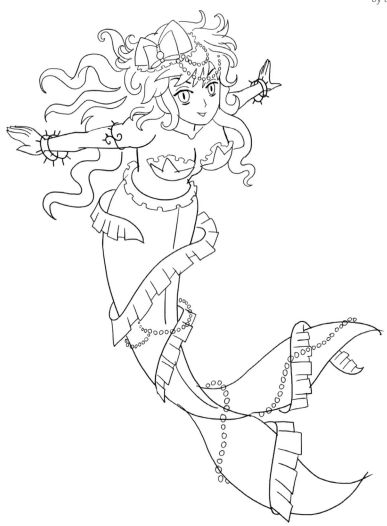

3. Inking and Layers of Colour

The inking is subtle and sinuous with hardly any straight lines. The dark blue of the ocean depths is the character's main colour, which contrasts with her pale skin and the pink and violet tones of the pearls.

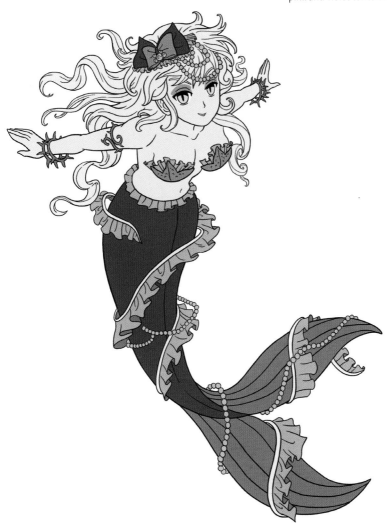

4. Lighting and Shading

Although fairly light shading has been used, particular care has been taken with the hair, to which the shading gives life and detail. To enrich the drawing, add detail to the tail.

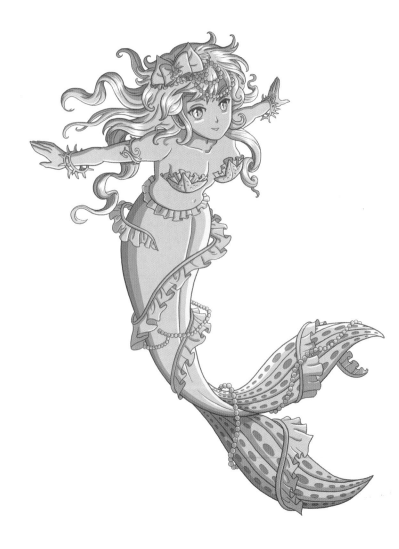

5. Finishing Touches

To finish off the drawing and give it a more magical touch, apply more layers of faint light all over the character, separating them according to the different areas of colour.

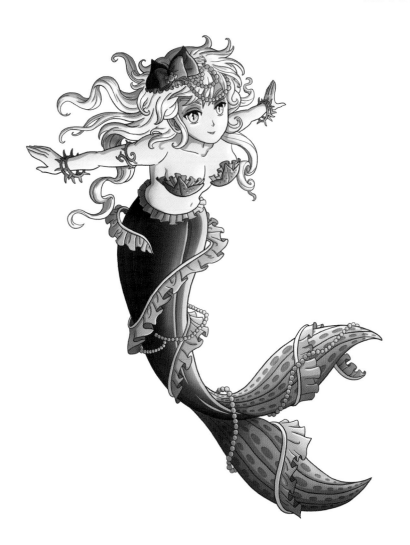

Nosferatta
Gothic Vampire

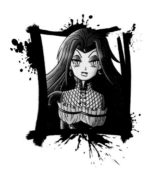

Nosferatta is an immortal vampire from the cold Balkan lands. This child of the night is forever damned to hunt prey to satisfy her thirst for blood.

1. OUTLINE AND SKETCHING

To give the impression that the figure is floating in the air, one knee is drawn higher than the other. The bent arms and the different position of her hands show sinuousness and control.

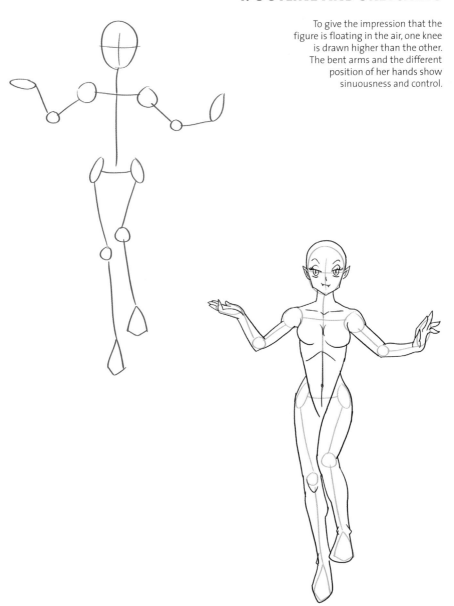

2. Pencilling

The vampire's long hair is well layered. The moon-shaped accessories complement and symbolise her character. The fitted bodice and high neckline give a sense of her belonging to a bygone age.

3. Inking and Layers of Colour

The inking stage consists of both long and very short lines. The colouring is a combination of dark greys and a vibrant cold blue that highlights the supernatural character of this vampire woman.

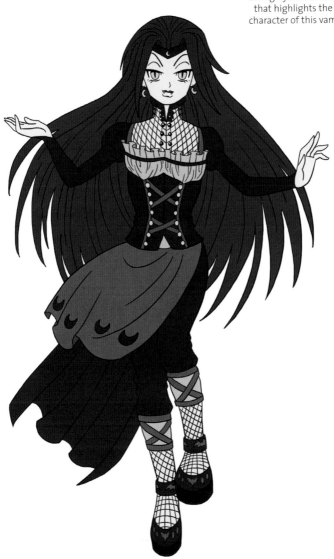

4. LIGHTING AND SHADING

The figure is dimly illuminated by
the moon. Shading is used to give
volume. Greater depth is achieved
by the dark shading behind her back
and on the tail.

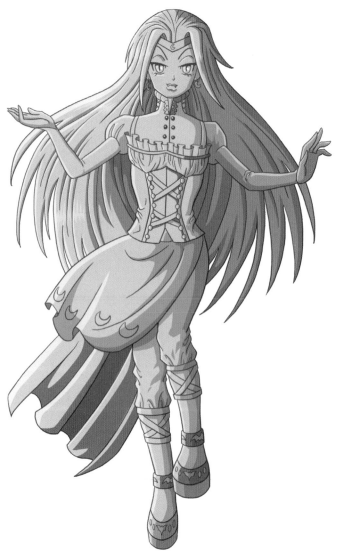

5. Finishing Touches

The blood-red eye shadow gives contrast and suggests an aggressive personality. A gentle light further suggests the moonlight falling on Nosferatta's beautiful hair.

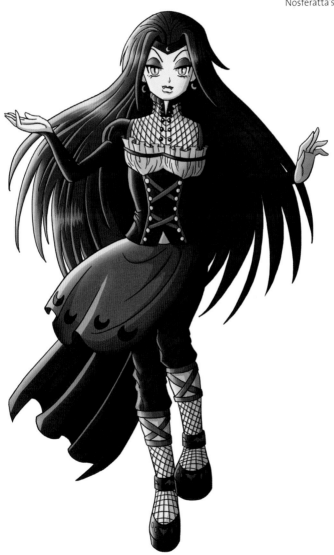

Acknowledgements

I want to thank Raquel, Fil,
José, Isabel and Darko for their
contribution to this work.